A
LIMITLESS
SKY

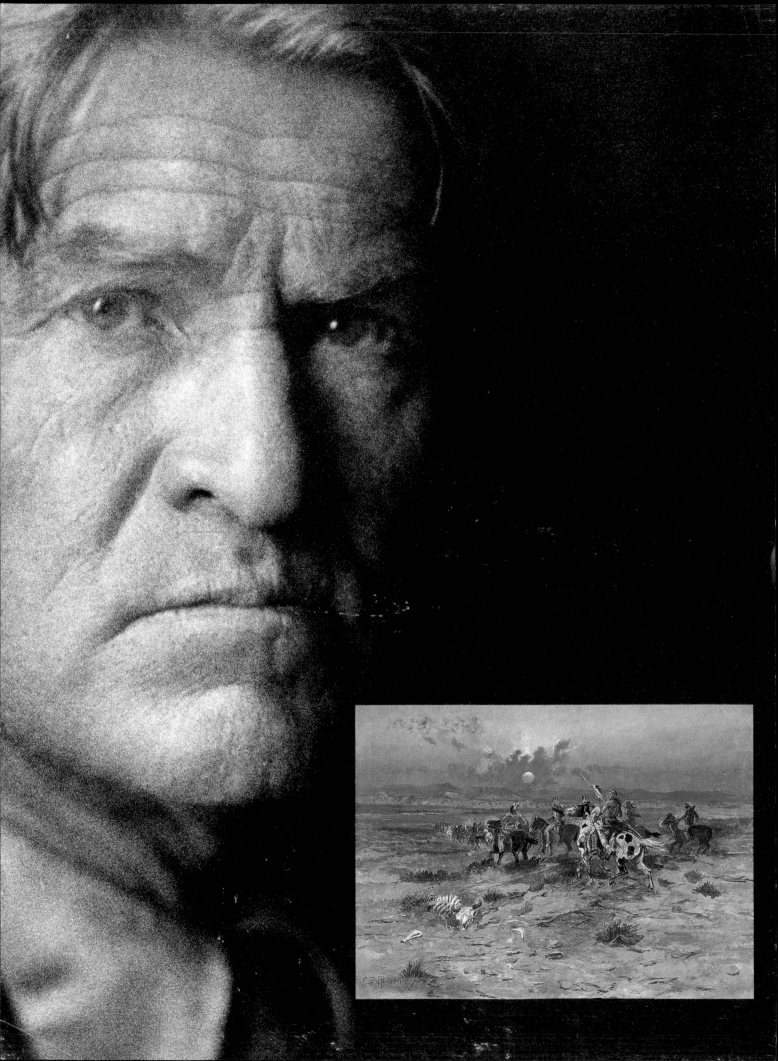

A LIMITLESS SKY

The Work of
Charles M. Russell

IN THE COLLECTION OF THE ROCKWELL MUSEUM, CORNING, NEW YORK

by Ginger Renner

Foreword by
Robert F. Rockwell

NORTHLAND PRESS
FLAGSTAFF, ARIZONA

*To Bob and Hertha, who gave me the
opportunity for a great adventure—
and to Fred, my mentor and best friend.*

FIRST EDITION
ISBN 0-87358-384-1 Cloth
ISBN 0-87358-385-X Limited Edition
Library of Congress Catalog Card Number 85-60941
Composed and Printed in the United States of America

CONTENTS

FOREWORD

I WAS INTRODUCED TO THE WORK OF CHARLIE RUSSELL AT A YOUNG AGE. MY father had four Russell prints in his library, and when I was three or four years old, I recall admiring *A Bronco to Breakfast, Jerked Down, The Cinch Ring,* and *When Horse Flesh Comes High.* However, I didn't see an original Russell until much later in life.

In 1960, my wife Hertha and I visited the Whitney Gallery (now the Buffalo Bill Museum) in Cody, Wyoming. To finally see the original work of so many fine western artists, including Charlie Russell, was a great thrill for us.

Dr. Harold McCracken, the director of the gallery and an authority on western art, noted my enthusiasm for Russell and recommended I contact Fred Renner, the acknowledged expert on Russell. However, before I had a chance to get in touch with Fred, he and his wife Maxine visited the Rockwell Company store in Corning. Apparently, Fred had heard about the Russells I displayed in the store. Before long, a strong friendship developed, and Hertha and I visited the Renners in their Washington, D.C., home many times. Sitting among the Renner collection of Russell originals, Fred and I would often stay up until two or three o'clock in the morning talking about the artist and looking at the thousands of Russell photographs Fred has acquired over the years. After spending many hours with Fred, I felt as though I knew Russell personally.

The following excerpt from Will Rogers's introduction to the book *Good Medicine,* which contains one hundred thirty-four Russell letters, best explains the personality of Charlie Russell:

It's hard for any man to tell what we did lose when we lost this fellow. No man, in my little experience, ever combined as many really unusual traits, and all based on One—Just Human, No conceit—You won't find a line or a spoken word ever uttered by him that would lead you to believe he had ever done anything that was

the least bit out of the ordinary. You won't find a line of malice, hatred or envy. (I haven't, as I write this, seen all the letters and contents of this book, but I just know it ain't there, for it wasn't in him.) He had it in for Nobody.

I think every one of us that had the pleasure of knowing him is just a little better by having done so, and I hope everybody that reads some of his thoughts here will get a little aid in life's journey by seeing how it's possible to go through life living and let live. He not only left us great living Pictures of what our West was, but he left us an example of how to live in friendship with all mankind. A Real Downright, Honest to God, Human Being.

Through our interest in collecting western art, Hertha and I have had the great satisfaction of making innumerable friends. It would take many pages to name them all, but I would like to mention a few who have helped me most in acquiring the Russells in the Rockwell collection. In addition to Fred Renner and Harold McCracken, they include Jack Bartfield, Victor Hammer, Rudy Wunderlich, Dean Krakel, Leo and Tony Lombardo, Helen Card, Michael Frost, Clara Peck, Earl Adams, Erin Hoy, George Montgomery, James Graham, and Ted Buckholtz, from whom I bought my first Russell. Jack Russell, son of Charlie and Nancy Russell, is also a good friend, and Hertha and I enjoyed having dinner in Bakersfield last year with Jack and Helen Russell and James and Astrea Rogers. James is the son of Mr. and Mrs. Will Rogers.

We are pleased that Ginger Renner consented to write this book and appreciate the vigorous effort that has gone into it. Ginger's expertise on Russell and western art is combined with a genuine admiration for the man, and I know of no one else who could better capture the essence of Charles Marion Russell.

ROBERT F. ROCKWELL

INTRODUCTION

I F ONE WERE TO JUDGE CHARLIE RUSSELL BY THE RESULTS OF THE FIRST half of his life, one would never place him among the ranks of "most successful men." He consistently (and bull-headedly) turned away from academic schooling, he willfully declined the opportunity for art training. When he got his wish and was sent to Montana by a loving and caring family, he was promptly fired from his first job. He spent eleven years drifting from one cow operation to another, night-herding the horse remuda in the spring and the cow herd on the fall round-up. During this period he owned no property, never had a permanent home, and seldom spent a winter without experiencing hunger at some point. When he made the decision in 1893 to "make it" as an artist, he experienced genuine depression and much uncertainty because commissions were few and far between.

Yet, as the years go by, it is increasingly apparent that Charlie Russell, the untrained cowboy artist, was extraordinarily successful, at least in the second half of his life. In those years, he achieved international recognition and enjoyed considerable financial success. With the passage of time, the number of devoted fans, admirers, and patrons of his art grows. Prices for his work escalate with each passing year. A significant number of museums in the South and West have admirable collections of his art. The Rockwell Museum in Corning, New York, with its comprehensive collection of Russell's art, now provides Easterners the opportunity to view and study the works of this remarkable man.

Almost six decades after his death, his art is more highly prized than ever. How did it come about that this most "American" of artists, who appeared to be a failure during the first thirty-one years of his life, should have gained such success? What components added up to such an achievement?

Fred Renner, the recognized authority on Charles Russell, was being interviewed recently and the young reporter asked, "Just what made Charlie Russell so great?" Renner quickly replied, "Some folks would say his wife!" Receiving the reaction he wanted,

Renner went on to analyze seriously the factors that played a significant part in the remarkable success of the cowboy artist.

Luck, as Charlie always admitted, had something to do with it. He was lucky to be born at the right time, to be in the right place, to experience first-hand a way of life that provided him with a body of material to draw upon for inspiration and artistic themes.

He had a natural talent in sculpting, but success in the area of drawing and painting came only after years of hard work, of trial and error, of intense observation of master works. He possessed a photographic mind and a keen artistic eye, but the ability to make violent action appear "correct," "fluid," "alive," was achieved through total dedication to mastering the techniques of realistic reproduction.

He was blessed with an insatiable curiosity about many things. During his life he read about, discussed, sketched, and painted such diverse subjects as "Iggeroties," a primitive people of the Philippines; William the Conqueror, and Henry Hudson, both of whom he brought down to size by referring to them as "Bill" and "Hank"; pirates; lady bartenders in London; the security of Napoleon's tomb; and the flora and fauna of Southern California.

Russell had an agile mind, and was able to dream up dramatic tableaus from the merest of suggestions. He also had an interesting and well-honed capacity to make startling comparisons: upon seeing a Seminole Indian in his native skirt, Charlie related him to a Scotch friend who wore kilts; he walked through Bowling Green and immediately peopled the area with Dutchmen in pantaloons, playing ten pins. In Charlie's fertile imagination, the mountain rats who nightly scampered over his Bull Head Lodge roof simply didn't like its design—they were up there with hammer and nails rearranging the shingles.

Russell had a very special sense of humor. This characteristic was perhaps the single greatest force in Russell's success. When he was a small child, all of the members of his family recognized that "Chas was such a funny little boy!" When he went as a raw teenager into Montana, his sense of humor played a large part in his acceptance into the round-up camps; as his career expanded, Charlie charmed railroad presidents, successful artists, the country's leading movie stars. He couched his philosophy, oftentimes very profound, in words meant to elicit a chuckle:

[From Southern California] "This was real picture country before the boosters got ahold of it and made real estate out of it."

X

[On hearing that Havre was "now a good and moral city"] "Reform is all right but reformers never broke trail to this or any other country. They came with the tumbleweed."

[To Teddy Blue Abbot] "I'm sorry you didn't get a gusher after punching all those holes in your ranch. Badger holes are bad enough on a cow range. Oil holes must be worse. Many a man's got a harder fall in an oil hole than them that a badger made."

[From the Tower of London] ". . . saw the ax and block where many politicians lost their office. I couldn't help thinking it might be a good thing these days."

Certainly, another element of Russell's success was his sense of theatricality. He had a very dramatic quality about his own person; in its most basic manifestation, he loved to "dress up" and play parts with groups of friends. His everyday appearance was one carefully calculated to create an image. His "half-breed" sash and the numerous rings on his long, sensitive fingers were designed to set the cowboy artist apart from most of the men of his extraordinary circle of friends. He insisted on wearing his size six, soft leather cowboy boots, even with an evening suit. But Russell's sense of theater extended far beyond the clothes he wore. His personal "proscenium arch" was the limitless big-sky country of Montana. On this stage, he choreographed the most exciting and dramatic scenes ever captured from Western American history.

In analyzing Russell's success, the luck and the talent, the imagination and the theatrical bent, and the sense of humor were all superceded by his deep, genuine, and abiding love for all aspects of "a time in American history." The cowboy who rode in rain and snow to drive the great herds of cattle; the Indians who were the real Americans in Charlie's eyes the gambler, the mountain man, the explorers, the prospectors and freighters—this was the cast of characters in his special artistic drama. Joined by the great drifting waves of the buffalo, the still majesty of a bull elk, the timid grace of white-tail deer, and the charm of the little animals, they played out their parts under endless skies, across river breaks and over sage-dotted prairies to distant mountains. All these Charlie loved, and captured in his oils, watercolors, sculptures, and illustrated letters. They will live forever through his eyes and heart, and they are the reason that Charles Russell was such a success.

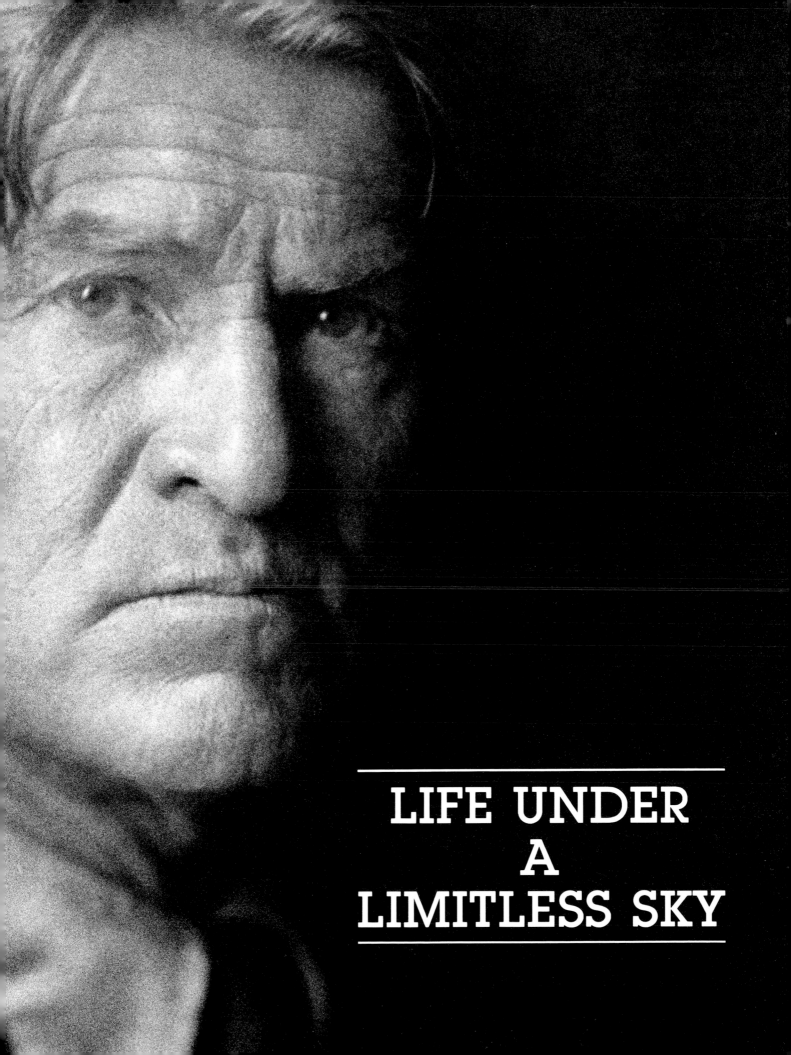

LIFE UNDER
A
LIMITLESS SKY

LIFE UNDER A LIMITLESS SKY

T HE RANGY YOUNG MAN STEPPED OUT OF THE COOL GLOOM OF THE BANK building into the heat of the afternoon sun. He squinted against the glare and ran a finger around the inside of his stiff collar edge. His worsted sack coat was itchy and uncomfortable, but he was campaigning for office and appearances were important. Thirty-year-old John R. Barrows, son of the founder of Ubet, Montana, was running for reelection to the State Assembly. For the past three hours, he had made his way slowly up and down the two-block Main Street of Cascade, talking to businessmen and handing out his cards. Across the street, hunkered down in the shade of Gorman's General Merchandise Store, he saw a familiar figure. The broadbrimmed hat was tipped forward, hiding the man's face, but a brilliant flash of red around his waist was a clear indication to Barrows of the individual's identity.

"That's got to be Charlie," Barrows mused to himself. "No other man in the state of Montana would go around dressed like that!"

He quickened his step as he crossed the dusty street. A visit with Charlie was always a treat, and Barrows, his hand outstretched, hurried over to the man.

"Russ, you son of a gun, good to see you! Haven't seen you since '89. You were still night wrangling in the Judith, but I'd heard you'd quit the game. How's it going for you?"

The man who stood up and took the outstretched hand was a good two inches shorter than Barrows, but the bulk of his large head and broad shoulders gave him a commanding presence.

"Barrows," he said, his somber expression unchanging. "Out rounding up strays?"

John Barrows was momentarily stopped. Then, "Oh yes, anything the opposition hasn't put a brand on."

"Sit down," Charles Marion Russell said. "Sit down and let's jaw awhile."

"What's wrong, Russ? You act like you drew three cards against a pat hand."

3

"You called the turn, Barrows." The eyes that many times had been characterized as fierce were glazed with despondency. "I'm just about whip-broke."

Russell reached into his coat pocket and pulled out a sack of Bull Durham. He began to "build a smoke." Barrows watched the long, tapered fingers roll the brown paper around the tobacco and twist each end neatly.

The two young men sat easily on their heels, leaning up against the wooden front of Gorman's store. They gave mute evidence to years of sitting where there were no chairs, in corrals or on the broad prairies of Montana.

Barrows, who had expected and looked forward to a funny story from Russell when he spotted him on the street of the small Missouri River town—a story that would have lightened the grind of campaigning—realized his old friend from the Judith River Basin needed some palaver.

"Hey, Russ, I heard from some of the folks in Helena that you'd gotten a good commission. Wasn't that true? Everybody's saying you're becoming an artist—a real artist."

"Wal, if eatin' only half the time will make an artist, I'm that, all right. I did pretty well last year. Had a good order from the Niedringhaus boys—five paintings—you 'member them, Barrows. Have that spread down on the Big Dry Creek. Though I guess they made their poke more on those fancy blue-and-white speckled pots than they ever done on spotted cows.[1] But you know me—I spent the take. When I got coin in my pockets I can't seem to quit buying drinks for the boys."

A slightly embarrassed grin momentarily changed the grim face. The blue eyes twinkled at the thought of some escapade with "the boys," the sort of mischievous prank that had characterized much of Russell's life since he had come to Montana. Then the eyes dulled again.

"I feel like I've been crowded up against a cutbank by a muley cow, Barrows. I pulled out o' the Falls last year 'cause I couldn't get any painting time—too many friends around playing all the time. Now, here in Cascade, there ain't anybody playing, but nobody's buying paintings either. I'm damned both ways."

He ground the last of his smoke under his heel and then pulled a black wad of wax from his coat pocket. Slowly working the dirty glob to soften it, the cowboy artist began to quickly form a small animal. Barrows recognized all the signs. He had seen Charlie entertain cowboys, ranchers, and townfolks with an almost sleight-of-hand talent, sometimes working under his broadbrimmed hat or under the edge of a table or bar, bringing out a perfectly formed deer, horse, bear, or pig for the delight of his companions. Barrows knew the artist used the ploy to entertain friends and hangers-on as well as to practice his skills. He also knew it was a nervous, compulsive habit, one that covered up Charlie's uneasiness and shyness.

As the sun dropped and the shadows lengthened across the street, the two men talked on, Barrows encouraging Russell to keep on painting, Charlie evidencing deeper despondency over his dilemma.

Barrows had never seen Russell so depressed and frustrated. He was surprised to

discover this side of his cowboy friend, whose statewide reputation rested as much on his delightful sense of humor as on his artistic ability. How, Barrows thought to himself, could a man with all this talent get to be thirty years old and feel like such a failure? How could it happen that the two of us could have started out in such similar ways and at midlife be on such disparate courses? Barrows had recently finished three years of study in the prestigious law firm of Wade, Toole and Wallace and, at the same time, had served his first term in the State Assembly. He had every opportunity ahead. Charlie, on the other hand, seemed to feel that his life was all behind him. Little did he know how wrong he was.

🐂

Charles Marion Russell spent the first fifteen years of his life in Montana as an itinerant, living first on the hospitality of friends in the Judith River Basin, then working occasionally as a night wrangler. Finally, after taking a major step toward a career as a full-time fine artist, he experienced several years as a frustrated, often despondent would-be painter.

Yet this thirty-year-old malcontent came from a long-established, successful family in St. Louis, the city that was then the premier gateway to the West. Family forebears included the Van Tassels and the Wolfert Eckerts, Dutch aristocrats of the Hudson River area, and the Russells of Virginia. By the time Charlie was born in 1864, the family had lived for more than forty years in a fertile and productive fiefdom.

Grande dame of the extended family was Charlie's grandmother, Lucy Bent Russell, widow of James, who had purchased the four hundred thirty two acres known as Oak Hill from his brother William sometime around 1810. More than one spacious family home graced the property, as did barns, meadows, slave quarters, vineyards, orchards, and, most importantly, the old Gravois coal diggings, original source of the family's affluence. By the early 1850s, the family's fortunes had been further enhanced by the establishment of the Parker-Russell Mining and Manufacturing Company, the largest producers of firebrick in the country.

Charlie, along with his brothers, sister, and some twenty cousins, grew up in an almost storybook setting. There were horses to ride, birds to shoot, fields to play war and "Injun" in, watermelon patches to scour, great oaks to climb. As long as the endless summers lasted, Charlie thought it was heaven.

Unfortunately, autumn came around regularly, and in accordance with the Bent-Russell tradition, all the children were given the best education possible, which Charlie, in a totally bullheaded manner, resisted. A young Episcopal minister was hired to come into the home and tutor all of the children so that everyone could help keep an eye on Charlie. Along with a regular academic program, the cousins were faithfully taken to Sunday school and church. Charles Silas, Charlie's father, enjoyed reading the Bible and Shakespeare aloud to his five sons and daughter, and all of them got doses of the period's moralistic literature. However, it was the art of storytelling that had a profound effect upon young Charlie.

🐂

It was an age of restless, adventurous pioneers. For more than three decades, mountain men, trappers, scouts, gold hunters, and simple emigrants had funneled through St. Louis

5

on their way west. The city's merchants were the outfitters for numerous expeditions; it was also the trade center for pelts and hides coming out of the far reaches of the Rockies. The legends, myths, and fascinating stories of the feats of the men of the West became folklore even while the adventurers were still striding across the vast landscape.

The Bent-Russell family had heroes of its own: Charles, William, George, and Robert Bent, Lucy's brothers. Charles Bent went into the fur trade circa 1818–1819 and by the time he was seventeen, brother William had joined him in establishing a trade line into Taos and Santa Fe. By 1833, the brothers had established Bent's Fort on the Arkansas River (in what is now southeastern Colorado). Associated with them in this very successful enterprise were men whose names are a roll call of the giants of western exploration: Kit Carson, Uncle Dick Wootton, Jim Beckwourth, Ol' Bill Williams, Tom "Pegleg" Smith. William Bent married Owl Woman, the daughter of the Cheyenne chief Gray Thunder, and with her had five children, all named for various Bent brothers and sisters back in St. Louis. Charles, leaving the operation of the fort to William, established himself in Santa Fe, marrying one of the beautiful Jaramillo daughters.[2] No one knows what the St. Louis Bents, living in a sophisticated and aristocratic society, thought of the addition of Indians and Mexicans to the family circle. But the adventures and successes, the exploits and tragedies of both Charles and William Bent were the core of the family's folklore. At his grandmother's Sunday table, young Charlie Russell heard the tales of their lives. His dreams developed early—he wanted to go west and live the free and exciting life that he imagined his great-uncles had known.

A succession of academically disastrous years followed one upon another. Charlie liked history, but spelling, sums, and penmanship held little charm for him. Rather than practicing the multiplication tables over and over, Charlie spent time sketching Indians and trappers, horses, and more Indians. He did not draw as well as his younger brothers, Ed, Guy, and Wolfert, but he never tired of trying. As they moved toward their adolescence, both Charlie and Ed learned to play the banjo and knew all the popular songs of the day, although Charlie was apparently tone-deaf. One area the boy did excel in was clay modeling. At about age five, Charlie discovered the outcropping of clay that was the lifeblood of the family's fortune. From that time on, he formed small animals from the material and fired them in the brick ovens. The family was charmed by this talent, but then, they had always said, "Oh, Chas is such a funny little boy!"

In spite of the encouragement and support of a loving family, Charlie was simply not interested in school. The regimen and discipline only inspired more innovative ways to play hooky. He carried memories of those years all of his life. In his book, *Rawhide Rawlins Stories,* published in 1921, Russell says: "As near as I can remember, them he-school marms we had was made of the same material as a bronco buster. Anyway the one I went to in Missouri had every kid whip-broke." And in an illustrated letter written to an old school friend in the early 1920s, Russell wrote:

I guess you remember old Smith our teacher and the li[c]kings he gave us. It has

been many years ago but he is still fresh in my memory as I suppose he is in yours. Well Charley we have both seen maney changes since those days. I am now married and setteled down but I of times think of our school days and baring the lickings I think we had a pretty good time.

In 1879, when he was fifteen, Charlie was sent to Burlington Military College, a New Jersey prep school, where he spent most of the semester walking disciplinary tours. When this idea proved a failure, the Russell family decided more drastic measures would have to be considered. A business acquaintance, Wallis "Pike" Miller, was leaving St. Louis and traveling to Montana to oversee the operation of his ranch there. Miller agreed to allow Charlie to accompany him and promised to employ the boy upon their arrival. The family assumed that a long summer in the wild and rugged environs of Montana Territory would soon dispel Charlie's romantic notions about life in the West. Surely a few months of hard work and deprivation would clear his mind of schoolboy dreams. It was perhaps the most erroneous assumption the Russell family ever made.

In the third week of March 1880, sixteen-year-old Charlie Russell arrived in Last Chance Gulch (now called Helena), and knew he had come home.

The big, rugged-looking man slouched easily in his saddle atop the bay horse and looked down at the young boy sitting disconsolately on a low bank by the small creek. The kid was methodically chucking small pebbles into the water.

"What 'cha doin', kid?"

"Campin'." The boy didn't look up.

The man shifted his weight in the saddle and glanced around the area. A fairly new but nondescript saddle and blanket lay on the ground next to a sloppily tied bedroll. Nearby, two ground-tied horses grazed, one a heavy-boned mare and the other a rangy sorrel.

"Where's your gear, kid?" the man asked gently.

"Right there." The boy pointed to the bedroll.

"Ain't got any grub?"

"Naw," the boy softly replied.

"Wal," the man said as he scratched his full, grizzled beard, "better throw in with me for the night, kid. I got some nice, fresh deer meat. Just dropped him an hour ago. I'm camped up the creek by those willows. Bring your stuff an' come along."

The man reined the big bay around and started up the creek. Suddenly, he pulled the horse up and, turning to look back, hollered, "Hey, kid, my name's Jake Hoover!"

7

The boy, standing now, with a faint grin playing around his tight-lipped visage, called, "I'm Russell, Charlie Russell."

Charlie couldn't believe his luck. An hour ago he hadn't a friend in the world. Dead broke, no grub, just fired from a job he hated, and, he had to admit to himself, a little scared. Now, here he sat in a real mountain man's camp, deer meat sizzling in a pan on a bed of hot coals, water heating in a lard can beside the fire, and best of all, Jake Hoover

mixing up a batch of biscuits. Jake Hoover! Charlie, even in his short time in Montana, had heard of Jake Hoover. Seemed all of the basin knew about Jake. Everybody said he was the best rifleman in the whole area. He could spot and drop game where other folks couldn't even see a twig move.

"Lucky!" the kid said to himself, and promptly put out of his mind the happenings of the past few weeks, when he had experienced some temporary erosion of his commitment to the West.

No one at home in St. Louis thought it necessary to emphasize that what Charlie was going to in the big sky country of Montana Territory was a sheep ranch. "Woolies! Dirty little boogers, dumb, too! Always going 'baa, baa, baa.' Straying off and getting lost down some coulee," Charlie was heard to complain after he'd been on the job a short time. Sheepherding was not what Charlie had in mind when he had dreamed of going west, dreamed of adventures and cowboying and total freedom from regimen and discipline. Nor was Pike Miller's attitude toward the sixteen year old what Mr. Russell had anticipated when he entrusted the boy to Miller's care.

They had traveled on the Union Pacific from St. Louis to Ogden, then by the Utah & Northern to Red Rock on the border of Montana Territory. From there, a stagecoach took them into Last Chance Gulch. Charlie had not minded the seemingly endless, dirty, spine-pounding journey at all, since every mile took him closer to the culmination of his dreams.

It had taken a number of days to outfit for their trip to the Judith Basin. The two stayed in the Cosmopolitan Hotel, a two-story hostelry in the center of the bustling mining camp. The government was distributing rations during their stay, and the town was full of Indians in colorful garb. The streets were also crowded with French half-breeds wearing broadbrimmed hats, brightly colored sashes, and carrying guns in fringed leather cases. And there were miners, gamblers, land speculators, and even some timid, drably garbed pilgrims like himself.

Charlie, determined to dress for his new life, purchased high-heeled boots and a buck-skin jacket. He also paid for two of the four horses Miller purchased to pull the wagon they would take to the broad valley of the Judith.

All too soon after their arrival at the ranch, the kid came a-cropper, not only with the sheep but with Pike Miller as well. The older man had little time or tolerance for the boy.

"Worthless tenderfoot," Miller snorted, talking to the experienced hands on his small spread. "The kid's lazy and irresponsible."

As Charlie said in later years, "I lost those sheep quicker 'n Miller could replace 'em." And with little thought of any obligation he might have to Mr. Russell for the boy's welfare, Pike Miller fired Charlie.

Jake Hoover stretched his legs toward the small fire, picking his teeth with a willow twig he had peeled with his sharp hunting knife. "Kid, maybe you'd like to come along with me up to my hunting camp. Got a nice little cabin up there on the South Fork." He tossed the twig into the fire. "Did you get enough grub?"

The boy grinned at him and rubbed his stomach in pleasure. He had told the whole story, recognizing as he talked to the older man that he probably had not come up to Montana expectations. He guessed he had some new things to learn. Hoover knew he had a real tenderfoot on his hands. But he also recognized something special in this young boy, something that ought to be nurtured.

Hoover, after successfully locating pay dirt at the Yogo mines, was now making his living by providing fresh meat for the miners and the scattered ranches and small settlements in the Judith Basin. No one did it better. Many years later, Jake wrote: "According to a memorandum I kept, I killed one hundred eight bears, not counting the ones I wounded that died later." And he was known to say, "I was never out of meat."

Jake knew more about the West than how to successfully kill game. He knew how men in this newly opened wilderness had to live, with each other and with the land. He passed this wisdom on to young Charlie Russell.

"Son," he said to Charlie one evening soon after returning to his hunting camp on the South Fork, "I recommend that you get rid of that mare. Not that she ain't a good horse—it's just that she'll lead all the other horses out of the country."

Charlie followed Hoover's advice. He also traded the sorrel that summer and thereby acquired a friend who stayed with him for twenty-five years. Jake and Charlie, with a load of fresh meat, had traveled from the hunting camp to the prairie country of the basin. On the way to one of Jake's regular customers, they came across a small band of Blackfoot who had moved into the area to hunt buffalo. With the band was a pinto the Indians called a ghost horse; several years earlier, he had been a mount ridden in an intertribal fight and had been stunned by a bullet and went down in the melee. However, he revived and joined the Blackfoot horse band. Thereafter, an aura of mystery was conferred upon the small, sturdy pinto. When Hoover and Charlie came upon the camp, the Indians were only too willing to trade the "horse that wouldn't die" and Charlie, in taking him over and renaming him Monte, acquired a friend. It was said, "If you know Russell, you know his horse." And Charlie always said, "Him 'n me understand each other." Monte was to live to an exalted age, dying in 1904, well cared for and much loved.

As the summer matured, so did Charlie. He was still a kid in a wide-sky, open, unlimited country, but he was learning from Jake how to live in this special land.

If Jake knew how to read the tracks of wild game, he also knew how to get along with men, at least with the men of this pioneer territory. Quietly, he passed on this wisdom.

"If you take a job, kid, do the best job you can." The two were riding up the trail toward Kelly Peak. Jake went on to tell of a miner he had worked with in the Gold Creek area when he had first come as a teenager to Montana Territory from Iowa. According to Jake, they had lost out on what proved to be a highly regarded claim simply because Jake had trusted his partner to file the proper papers, but the miner had failed to do so.

It was the first time that Charlie realized that Jake didn't completely approve of his negligence in allowing those sheep to stray. Jake had never mentioned it, but Charlie understood there had been a purpose in the story. Then and there, Charlie promised

himself he'd show more responsibility if he got another job.

Other good, solid advice offered by the mountain man to the young boy included the following:

A man's word ought to be the only promise you need, kid.

You know, kid, you ought not judge a man too harshly. You can't be sure how you might act if you was in his shoes.

Better not tell a story on yourself where you come out looking good. Folks'll call you "Windy."

You go into a ranch house, kid, when the folks ain't home, it's all right to fix a little food. Only wash your dishes! Folks 'preciate it if you chop a little extra wood, too.

Jake Hoover was a big man, over six feet tall and powerfully muscled. Charlie had to look up to him in many ways. Hoover not only had a reputation as a great game hunter, but was also known as a friend to all. Charlie wasn't the only one who stayed for weeks at a time in the hunting camp. S. S. Hobson, a man who had come from Iowa to build up a herd of beef cows in the basin, also bunked from time to time with the big, jovial hunter. Small, wandering bands of Indians who weren't welcome in many places in Montana Territory knew they could always get decent treatment and a good handout of food from Jake Hoover. "There's probably some bad Injuns, kid, but then there's some bad whites as well."

There was a soft and sentimental side to Jake Hoover that Charlie loved. Hoover had long put out salt licks around his cabin, and deer came regularly to enjoy them. These, as well as all other small animals who seemed to have an affinity for the big man, were off-limits for killing. "You don't feed something and then shoot it, kid."

During the long, idyllic summer of 1880, Hoover was not the only friend Charlie acquired. Not far away, in Pig-Eye Gulch, lived the Babcocks. Mrs. Bab, a warm and affectionate woman, was known as a good cook and many a stray visitor gladly sat around her table. Ol' Bab, or Lyin' Bab as he was known in those parts, was an irascible but often congenial host, spinning the biggest "windies" to be heard in the basin, to the delight of his guests. Charlie found his way to the Babcock's often during the next few years, and many of the stories for which he became famous derived much of their material from Ol' Bab.

10 The Judith Basin had just been opened for settlement the year before, and men from many areas of the Midwest were spilling into this pristine country, eager to gamble on cattle and sheep. One such man came to the basin in 1879. William Edgar, third son of a prominent and successful St. Louis family, was related to Charlie through intermarriage with the Carr family. The first time Jake had to take a load of hides to Fort Benton, he said to Charlie, "Kid, why don't 'cha take a ride down to the Edgar's place. Know you don't think much of sheep—and the old man's sort of standoffish—but those folks come

from your home town. They got a small spread about three miles east of the stage stop . . . can't miss it . . . be good for you to see some folks from home. I won't be gone more than a week."

And so, two days after Hoover left the kid in the vastness of the south Judith, Charlie threw his bedroll on Monte's back and found his way to the Edgar's small sheep spread. Because he was the son of an old and respected St. Louis family, he was made welcome by Mr. and Mrs. Edgar and most especially by twelve-year-old Laura, who was spending her second summer isolated in a land bereft of young folks. Charlie, sixteen and charismatic beyond his years, was taken with the family's both southern and western hospitality.

Riding back from Edgar's place, Charlie was joined on the trail by another young man. From Charlie's superior position of a five-month residency in the basin, he recognized a rank pilgrim. Brand-new saddle, city clothes, but a new, broadbrimmed hat.

"Where're you headed?" he asked the boy as they rode along together.

"I'm going to join my family up at the head of the Judith. My father has just put in a sawmill up in the Belt Mountains. Hope I don't have any trouble locating it. I'm anxious to see my father. The family came out from our home in Wisconsin last year—haven't seen them since. I had to stay behind to finish school.

"Wal, I just got here in March," Charlie said, suddenly willing to reveal that he was something of a newcomer himself, "only I didn't finish school. My folks gave up on me doin' that and let me come anyway."

"Are you working around here?" the boy asked.

"Naw, at least not yet. I'm staying with a meat hunter up the South Fork. I worked awhile for a sheep rancher—I *hate* sheep! I want to work on the roundups."

"That's my goal, too!" The boy shifted in his saddle. "I may have to work in my father's mill, but I hope not. 'Course, I'd really like to be an Indian fighter, or maybe a scout. I guess a scout would be better."

Charlie looked directly at the profile of the tall, slim boy riding next to him. Here was a kindred soul—someone with the same goals Charlie had.

"Say," he said, "my name's Charlie Russell." He didn't ask "what's your's." As Jake told him, "Never ask a man's name, son. If they want 'cha to know, they'll tell you. Lots of them don't."

"Well, mine's Barrows," the boy replied, "John Barrows. And I'm glad to meet you. You're my first acquaintance in Montana."

"Barrows," Charlie mused. "I heard 'bout your dad. Gotta friend up in Pig-Eye Gulch, name's Bab. Ol' Bab said he'd heard your dad was cuttin' some timber 'n he was gonna order some for a new corral at his place. My partner, Jake—Jake Hoover—he said he'd heard your dad was fixing to build a hotel up on the Carroll Trail, 'bout where the road to Yogo cuts off."

"That's not a surprise," Barrows said. "When my father came out here last year, he had a lot of big plans."

Hitting the broad and dusty Carroll Trail—the stagecoach line to Diamond City and

Helena—the boys rode slowly on, continuing to exchange information. They discovered that they had been born within a few days of each other, and they both had long wanted to leave their respective homes in the Midwest and come to this exciting land. They both liked the legends that had come out of the West, and both thought Ned Buntline stories were the greatest.

When they came to the junction of the South Fork and the Judith, the boys shook hands, wished each other luck, and went their separate ways. They were to meet many times in the next fifteen years—at Ubet, the small town in the gap between the Snowy and the Belt mountains, founded by John Barrows' father, and at Utica, another community that sprang up along the stagecoach route. But they never worked a roundup together, for Barrows signed on as a wrangler for the DHS outfit on the Musselshell, and Charlie went with the OH in the basin. Neither one became an Indian fighter nor a scout.

There were others who figured in Charlie's new life: Nelson True (Ol' Man True) and Hiram Sweet came from Iowa; S. S. Hobson, also from Davenport, was instrumental in enticing many of these men to come West, and together with True and Sweet, formed the 101 cattle operation. Ensign Sweet, son of Hiram, was known to all as Anzie and became Charlie's working partner and close friend. Another group of adventurous entrepreneurs came upriver from St. Louis. In addition to Edgar, there were the Harrells and the Crowells. From New York came John Waite and from Michigan, Jesse Phelps. All were looking for the unbelievable opportunities offered by this rich, wide-open land.

Charlie thought he had walked into pristine country, the kind his great-uncles and their cohorts had known more than sixty years earlier. What he didn't know—and it's just as well that he didn't—was that Montana Territory was on the verge of a population explosion. Between 1880 and 1890, the territory's population jumped three hundred sixty-five percent![3] Never again was there such an influx into Montana. The tidal wave of emigrants swept away the dreams that had lured Charlie Russell west. But for the moment, it was simply a big country, full of excitement, full of promise, and open to everyone.

In March 1881, Charlie was in Helena, once again at the Cosmopolitan Hotel. Heading back to the basin by way of Diamond City and Copperolois, he ran into John Cabler taking a herd of beef cattle toward the Judith. Short of hands, Cabler was glad to hire an inexperienced wrangler, even a seventeen year old, for the drive into the basin. It was Charlie's first experience as a cowboy and it tested his mettle. The winter of 1880–1881 had been unusually severe. The area from the Musselshell to the Highwood Mountains experienced extremely low temperatures. Snow, which fell early in the fall, melted after a chinook in mid-January, but more piled up as the winter waned into an undefined spring. Through the Judith Gap, the endless wind blew cold and raw. The wild, rangy cattle were unmanageable; bed grounds never warmed enough to still the miserable animals. The hands needed a tremendous amount of skill and an unremitting loyalty to the outfit in order to hold the herd on the trail. Working day and night, sometimes in the saddle for twenty-four hours straight, the crew finally moved the herd into the broad, grass-rich area of the Judith. Turning the herd loose east of Arrow Creek, Cabler paid off Charlie, and the kid made his way back to Jake's cabin to spend the summer months in land he said

was "better than a king's domain." Charlie, low man in the hierarchy of the trail drive, had watched the experienced hands carefully, learned his lessons, and knew, more than ever, that he wanted to be a cowboy.

There was a hypnotic rhythm to these early years in Montana, at least for the cowboys, who were quite unlike any breed of men known before—or perhaps since. The winters stretched on forever and were usually filled with days of hunger and boredom. For those without families in the territory, and there were many, it meant holing up in some small community and eking out an existence until spring. Worse than that was riding the grub line: going from ranch to ranch, doing a few chores, getting some meals, and moving on. Then May would come, and the punchers would borrow money from friends or the bartenders in town, get their saddles out of hock, and sign up for the spring roundup. This was a six- to ten-week job that was designed to gather in all cattle and newborn calves, many of which had drifted over a hundred miles or more from their original pastures during the winter. The calves would be branded and cut, doctored when necessary, tallied as to ownership, and turned loose again. Mid-July found the punchers and wranglers, the camp cooks and herders, out of work again. But the long, warm days of summer unemployment didn't pose the problems that winter did. Some got temporary jobs, shoeing horses or cutting hay, and some hired themselves out as handymen. By the first of September, the fall roundups were organized. These were the big ones: often fifty or sixty different ranchers pooled their resources, hired a captain, a foreman, a cook, and wranglers. Each owner sent at least one rep—a cowboy representing the owner's brand—who had to be aware of the other brands as well. The captain was an absolute boss, with the foreman second in command. Following the roundup itself, the beef herd had to be cut out and driven long miles to a railhead for shipment to the midwestern and eastern markets.

The entire crew was expected to put the welfare of the herd above everything else. Of equal importance was their loyalty to their home outfit. Misfits had no place in this specialized society; those who couldn't abide by the rules were quickly dismissed. There was no drinking on a roundup, and many outfits wouldn't tolerate gambling of any kind. No fighting among the men was allowed—if a couple of punchers got crosswise with one another, they were expected to put it aside until the roundup was over.

By the standards of the day, they were well fed; in return, they got up before daylight and often worked around the clock, in rain, snow, and on dusty trails. It was little wonder that when they were finally paid off, they rode to the nearest town, bought new clothes, had their hair cut, and squandered the rest of their pay on whiskey, women, and the gambling tables. After this, they holed up once again in some little line shack and waited out the long Montana winter.

They were, for the most part, young; many had few or no familial ties. But the life they led created a fraternity among them that did not dissolve with the years. Throughout their lives, these men had a spirited affinity for each other. Charlie Russell often said, "Our friendship was the kind that long dusty trails and cold, wet camps make."

13

In the late summer of 1881, the first Judith Basin Pool was formed. Organized by Hobson and Hiram Sweet, all the major cattlemen of the area met and planned this joint roundup. They chose as foreman Horace Brewster, one of the most reliable and experienced men in the basin. Following the branding and the tally, the herd was to be delivered to Miles City for shipment to eastern markets.[4]

One of the horse wranglers for the pool was a half-breed adolescent named Pete Van. An excellent rider with ambitions to be a bronc buster, Pete was full of spit-and-vinegar. Spending many of his daylight hours around the horse herd, or cavvy, perfected his skills but also tired him out. As a result, he naturally went to sleep while on night guard duty. Brewster complained to Hobson about Pete's lack of responsibility, but he didn't want to fire the boy since that would leave him short-handed and it was too late in the season to find a replacement.

Hobson said, "Horace, why don't you try that kid who's living with Jake Hoover? He's dying to be a cowboy."

Brewster sent word of the job opening, but when Charlie showed up several days later—bedraggled, tow-headed, tight-lipped, and inarticulate—Brewster had some reservations about trusting him with the valuable horse herd. Calling in an older, experienced hand, Brewster said, "Go out with this kid for a night or two and see how he does."

The man came back after a second night and reported, "Wal, Horace, that kid's gonna be all right. He's a damned sight smarter than he looks. 'Course, he holds 'em up pretty tight . . . don't let 'em graze like they should . . . but I think he'll be okay."

And Horace replied, "That's okay. I'd a damned sight rather ride a hungry horse than be walking around lookin' for 'em every morning."

Hold them he did. Too tight at first, but then, he was scared: scared of losing the job, scared of losing the horse herd (so crucial to the roundup's success), scared of the responsibility, and often just scared of the long, hard nights. But he learned to do it and do it well. For that, he was paid somewhat higher wages than the regular punchers, and was pretty much his own boss during off-hours. He never got enough sleep, but since he didn't have to work during the daytime, he had time to sketch and paint little watercolors that amazed and intrigued the rest of the crew. After the evening meal and before he went on duty, when he would ride slowly around and around the horse herd and softly hum prairie songs, he had time to sit by the campfire and tell the hilarious stories that he had mentally conjured up during the day. He was the best entertainment the roundup crew had ever had. His unscheduled hours also allowed him time to plan the high jinks and the wild, practical jokes that became part of the legend of Charlie Russell.

14

The spring roundup of 1884 ended in mid-July, and Charlie headed for Utica with joy in his heart: he had been offered a commission for a painting! J. T. Murphy, owner of a big outfitting and general merchandise store in Helena as well as a good-sized herd of cattle in the Judith area, had come out during roundup to check his calf crop. Several members of the roundup crew showed Murphy some of the small sketches Charlie had made of camp and branding scenes. Murphy looked up the young cowboy and proposed that

Charlie do a poster for him, illustrating some of the gear his store offered.[5] It was Charlie's first commission, and he was excited. Ideas for the design ran around in his head like squirrels in a round cage. He suddenly thought, I got to get some better paints and a big poster board. Better order it up from Billings, I guess. Maybe I'll have to send all the way to Butte. I'll have to stay around close 'til it comes; maybe I can bunk at the Edgar's place.

The Edgars, as always, welcomed Charlie, and when his supplies came, they urged him to stay on while he painted. Charlie had the design worked out—he wanted it to be exciting, not just a painting of a bunch of gear. He was going to do a stagecoach with a six-horse team coming down a road, just like he'd seen on the Carroll Trail—hell-bent for leather. Maybe around the sides he'd do some other pictures; a cowboy in fancy gear would be good—there wasn't a cowboy in the territory who didn't like fancy gear, and Murphy's had a lot of what they liked. Maybe he'd add a freight wagon drawn by a bull team. Boy, those teams were powerful, and they brought in a lot of the stuff Murphy sold. He also sold a bunch of farm tools and equipment, but Charlie'd be damned if he'd paint any plows!

By the time the piece was finished and shipped off to Helena, there was more than one reason to hang around the Edgar spread. Of course, he had to stay to receive his money; that is, if Murphy liked the piece and paid him. More importantly, Laura Edgar had turned sixteen and suddenly, for the first time, Charles Marion Russell was in love. Laura—Lollie to family and to Charlie—was a diminutive young lady with slightly curly hair and soft brown eyes. Billy Shaules said she was "pretty as a white-faced calf," high praise from a cowboy. Charlie thought that she was the nicest thing that had ever happened in his life.

For Charlie, that summer was probably one of the best. He knew that he could always get a job on the roundups, he had sold a painting for a decent price, and he was in love: heady stuff for a twenty year old.

Mr. Edgar, although desperately trying to make his sheep ranch pay off, had time to recognize what was happening right in his own home. That child, that precious daughter, was certainly not going to get involved with a cowboy, an itinerant, seasonal worker, at that time only slightly higher on Montana's social scale than an Indian.

In 1886, when Edgar gave up on his Montana investment and moved his family back to Missouri, the family set about turning Laura's attention from a totally unacceptable cowboy to a proper social lifestyle in the aristocratic milieu of St. Louis. Bullheaded and single-minded as always, Charlie continued to hope that he could win approval of his suit for Lollie's hand, and made a number of trips to St. Louis during the next few years. For Laura, the brief attraction became but a gentle memory of long-ago summers in a far-away land. For Charlie, though, the experience triggered an emotional flood that washed over him and that he never forgot.

15

The summer of 1886 was hot and dry. Streams that had always run were bone dry by August. There were now more than a million head of cattle in Montana, whereas six years earlier, cattle numbered in the thousands only. The bands of sheep had likewise increased, and land that a few years previous had been deep in native grasses was now being overgrazed. Early November brought a severe storm, and by the middle of the month, the

temperature had dropped below zero. The ducks and geese had flown south early, and even birds accustomed to staying for the winter had disappeared completely. Everything pointed to a hard season. December brought more snow, and on January 15, the temperature dropped to forty-six degrees below zero. Snow was everywhere, drifting and piling up in icy shards around the corral fences and filling the coulees. By this time, the cattle on the range were thin and weak, unable to paw through the ice crust to find any grass; they died by the thousands. Great herds driven up the Texas trail late in the fall were completely decimated by the extreme cold.

Despair hung heavy over the range. Charlie was wintering with Jesse Phelps at the OH headquarters, east of Utica. One particularly cold afternoon, Jesse sat at the table in the small kitchen, warmed by the dying fire in the cook stove. Billy Shaules, a cowboy Charlie had worked with on several roundups, was there, as was sixteen-year-old Finch David. Finch had come over from his father's place on the Judith and brought the mail, fighting through drifts most of the way. A note from Louis Kaufman in Helena inquired as to how his and Stadler's cows were weathering the bad winter.

Frost covered the only window and the room was as gloomy as the men's attitude. Charlie sat across the table, doodling on a scrap of paper; he felt badly for Jesse—he knew how hard it was to tell a man he's lost most, if not all, of his herd. He also knew something else: change was rushing in on the basin—the cattle and sheep competing for the grass, the whole place being built up, little ranch outfits everywhere—where only six years before there had been endless empty miles of rich grassland.

"I just don't know how to tell Kaufman he's lost his herd," Jesse Phelps lamented, throwing down his pencil.

"Wal, send him this," Russell said, giving his boss a small, postcard-size drawing. On the card was a bone-weary, emaciated cow standing in a blizzard. Around her, several wolves skulked in anticipation of her imminent collapse. Under the drawing, Charlie had written, *Waiting for a Chinook.*[6]

"Well, that says it all," Phelps said, as he slipped the small card into an envelope and addressed it.

Legend has it that Kaufman, upon receiving the drawing and recognizing the magnitude of its message, promptly went out and got drunk. Whatever the case, it is known that the card fell into the hands of Ben Roberts, a saddlemaker in Helena who was already an admirer of Russell's sketches. Roberts had the card photographed and printed, and it became the means, more than any other communication, of advising cattle investors in the East, in Canada, and even in England, of the disastrous situation. The small drawing also established Russell's reputation as a cowboy artist. Thereafter, he was known far and wide as the one who let the world know how bad things were in Montana in the winter of 1887.

❦

The four riders, two of them leading packhorses, topped the ridge on the north side of the valley and paused on the trail to look back to the south. The mining town of Helena, spilling down the side of the mountain, seemed far away.

"Wal, we won't see that burg for quite a spell," one of them announced.

"I reckon it's just as well," Charlie Russell said. He pushed his hat back and rubbed

his forehead with his sleeve, wincing as he did so. "Boy, I must'a tried to drink all the joy juice in the Gulch last night."

"You won't get a chance to drink any more for a while," his dark-haired companion vehemently commented.

"Aw, Weinhard, I already told you I was sorry to miss your wedding." Charlie grinned at the young man, his expression signaling a request for forgiveness. It was not forthcoming. The riders moved on over the hill, heading north.

The date was May 16, 1888, and Phil Weinhard, an actor from the cast of *Montana in '64,* a play then running at Helena's Coliseum Theater, was hightailing it out of town. The thespian, married at 7:30 that morning, was at the moment *sans* bride. With three companions, two of them suffering from the effects of a long night at Auntie Fats', he was judiciously removing himself from the wrath of his former employer, Chicago Jo Hensley.

"I'd sure like to have heard Jo when she discovered that Mary was gone." Charlie, who always enjoyed a brouhaha of any kind if he was on the sidelines, chuckled to himself at the thought. "She may not be able to read, but that woman's handy with words."

The woman under discussion, Chicago Jo Hensley, was one of the power brokers of Helena. She may not have been acceptable to the town's social registry, but she carried weight with the bankers and real estate developers in the bustling mining camp. Josephine Hensley had started with a hurdy-gurdy (dance hall) in the late 1860s. Fifteen years later, she owned the largest variety theater in the midcontinent. Theatrical acts of top quality jumped from Minneapolis to Helena to play on Jo's stage before moving on to the West Coast. One of her staff in the winter of 1887–1888 was a young Canadian, Phil Weinhard. He played various parts in the winter-bill set pieces and helped out as a bookkeeper for the theater and saloon operations. He also fell in love with Jo's niece, Mary.

Coming off the fall roundup, Charlie holed up in a two-room shack with several other out-of-work cowboys. Theatrically inclined, Charlie was always intrigued by actors and performers, and Weinhard, conversely, had a genuine interest in art. The two met and became good friends. When Phil and Mary decided to marry, they both knew that Mrs. Hensley would not accept an itinerant actor into the family, and an elopement was planned. Charlie, with the help of Long Green Stillwell, a young jack-of-all-trades proficient at faro, had arranged to surreptitiously remove Mary's clothes from her room in small batches and store them for an eventual getaway.

Weinhard wrote to friends in Alberta, securing the promise of employment on a ranch twenty-four miles southwest of High River. When the wedding was finally arranged, the late spring runoff was so high that Phil knew he could not subject Mary to the dangers of crossing the many streams and rivers that lay between them and the small Canadian community. He arranged for Mary to go to his brother's home in Minneapolis by train immediately after the ceremony; she was to wait there until he could send for her. As accomplices to the elopement, Charlie and Long Green knew they had also better absent themselves from Helena.

Weinhard had previously worked for several years as a mail carrier and dispatch rider between two survey camps along the Kicking Horse River and was well acquainted with many of the Blood Indians living in that area. On the trip north, Phil took advantage of

17

long hours in the saddle to teach Charlie the rudiments of sign language. Neither of them realized at the time that this would prove to be one of the cowboy artist's most valuable skills.

☙

The few months he spent in Alberta had an effect upon Charlie that would last a lifetime. Since early boyhood, he had been fascinated by Indians, and members of many tribes were the subjects of his earliest sketches and drawings. These sprang principally from his vivid and romantic imagination and were greatly influenced by often-erroneous descriptions found in pulp magazines.

During his first years in Montana, wandering bands of Sioux, Crow, and Blackfoot were still engaging in cattle- and horse-stealing raids, and the opinions of most Montanans concerning Indians were negative. Charlie, who harbored many fears—of heights, of scary trails, of snaky broncs, and (quite reasonably) of the power of a surging herd—had justifiable fears of Indians, as well. He told the story of being alone in Jake's cabin cooking breakfast when he was suddenly joined by a large Indian who signed that he was hungry, *very* hungry. Charlie recounted his fear and how he cooked pancake after pancake as quickly as he could in order to satisfy his unwelcome guest and get him on his way.

But the underlying fascination he had long harbored for Indians won out over any hesitation. He began to seek out Indians, to see how they lived, to observe their ceremonies, to trade bits and pieces, to make sketches. All of the years he was on the range, he carried in his "war bag"[7] a small, tanned, and painted buffalo robe that he may have traded for a portrait sketch. The Indians came to sense a special quality in the young man, and they welcomed him.

In High River, Weinhard introduced Charlie and Long Green to an Englishman, Charles Blunt, who turned one of his empty cabins over to the boys. Blunt, an amateur painter, also loaned Russell canvases, paper, and paint. Two paintings and several water-color sketches came out of this adventurous summer. One, the first of the Royal Canadian Mounted Police paintings, was the result of Charlie's observation of a red-coated Mountie bringing two Blood Indians into town under arrest. Charlie gave the oil to Blunt, apparently in lieu of rent. The other oil, *Bear at Lake,* now in the Rockwell collection, was left along with several small watercolors when the boys headed south. Weinhard, coming into High River for provisions, found that the two had left town, and he appropriated the art-work. Long Green had traveled south on a horse and saddle belonging to Weinhard, who probably took the painting and sketches to cover the debt. Forty years later, he sold them to Homer Britzman.[8]

The importance of that summer, however, was not measured by the quality or the quantity of the art produced by Charlie. Something of infinitely greater significance took place. On the outskirts of the small Alberta town were camped several groups of Blood Indians. Others, Blackfoot and Sarsees, were constantly moving throughout the area. Having acquired sufficient skill at signing, Charlie was able to communicate with these nomadic bands, and began to make friends with a group of people who had, for much of his life, a deeply genuine—if romantically oriented—influence on him. He sketched their beadwork,

their trappings and gear, their clothing and domestic items. That he could make recognizable portrait studies of his new friends made him something of a medicine man to them. He was soon welcomed into their lodges and their daily lifestyle became familiar to the eager young man. They shared the legends and stories of their tribe. Woven through these were their deeply rooted beliefs, the tenets of their religion, their daily commitment to powerful spiritual and natural forces.

A metamorphosis took place. As they recounted the proud and glorious moments of their past, Charlie began to see them as they once had been, and this became his dominant view. Charlie committed to his prodigious memory the bits and pieces of their lives—lives they had once known, before they were reduced to reservation status by the white man's invasion. Out of the many hundreds of paintings, watercolors, and sketches Charlie Russell produced using Indians as his theme, only a handful reveal these natives in the reduced circumstances in which they were living when Russell came west. As he had formulated his boyhood dreams of western life on patterns that were already part of the past, so he now transformed the lives of his favorite subjects, placing them forever in the heyday of their history.

Mame Mann, Nancy Cooper: she went by both names at various times in her young life. She was eighteen, plump, with light-brown hair and wide-set, grey eyes. On the afternoon of September 9, 1896, in a sweet and unpretentious ceremony in the parlor of the Ben Roberts home in Cascade, Montana, she married Charles Marion Russell. Most of the guests (and most of their friends not in attendance) shared two emotions that day. They loved and genuinely cared about one or the other or both of the newlyweds, but all had serious reservations whether they should be joined in holy matrimony.

"You're makin' a mistake, Mame," Mrs. Roberts said. "He can charm a monkey out of a tree, but he's not for you. He drinks too much, everybody knows he's lazy, and he'll never be able to make a decent living. How can you make a living just painting pictures of cowboys and Indians?"

Doc Sweet, on the other hand, had taken Charlie aside one day and told him, "Son, you are taking on an awful responsibility. She's got a bad heart, you know. Faints just dead away! Probably had rheumatic fever sometime. You aren't used to looking after anyone but yourself. This wedding you're talking about—it's a mistake, Charlie."

But, paying as much attention to good advice as most young people do, Charlie and Nancy, delightedly and happily, went into "double harness." What resulted over the years was an almost perfect match of two opposites, two complex personalities, two people who complemented one another. With their diverse talents, they brought success, fame, financial gain, a stable home life, mutual respect, and a remarkable understanding of each other's strengths and shortcomings to their marriage. By and large, the world outside their partnership never truly understood that they were just right for each other.

Nancy Cooper (Charlie always called her Mame) was the issue of a brief marriage. Her father didn't know that she existed until she came back to St. Louis as Charlie's wife and he read about her in the local newspapers. Her mother died in Helena, leaving Nancy and

19

a much younger half-sister, Ella Mann, to the mercies of some good folks of that rough mining town. In 1895, seventeen-year-old Nancy was living-in with the Ben Roberts family in Cascade, downriver about sixty-six miles from Helena. She wasn't a maid—Montana folks like the Roberts didn't have maids—but she helped with the young ones, cooked, did chores, and was part of the family. She was pretty, energetic, and bright.

Charlie, thirty-one and struggling to make a living as a painter, had long been a favorite of Ben Roberts. Ben was shrewd and quick-witted, and envisioned opportunities to make money from Charlie's talent; he also genuinely admired the young man and had long been his friend and supporter. It was Ben who invited Charlie home for supper and introduced the couple. Charlie always said he was lucky, and never more so than when he met and fell in love with this young woman. Through her unremitting devotion and insatiable ambition, Nancy made him the most successful western artist of his time.

Despite rumors and petty asides (made primarily by Charlie's friends), there is not the slightest evidence, either in letters or in interviews with long-time friends of the couple, that Charlie ever "bowed his neck" or "dug in his heels" against Nancy's management of their marriage. Of course, fighting against something was not Charlie's nature. Not openly, at least. John Barrows said about Charlie that "he was the type which adapts itself to surrounding conditions and makes the best of it. Discontent was not part of his makeup."

Certainly, discontent was not apparent in those first difficult yet hopeful years. From the onset, Nancy was sure that Charlie was a very special man with talents so superior that the world should be made aware of his exceptional qualities. To her credit, she never gave up this challenge.

Charlie was delighted with an adoring and totally supportive helpmate. She was quick and vigorous in all of her movements as well as in her capacity to make decisions, a sharp contrast to the physical lethargy that marked Russell. Charlie painted, cared for Monte, and if some of his sketches are to be believed, sometimed wiped the dishes following their evening meals. However, hard physical labor, the kind known by most Montana folks in the 1890s, was not something that Charlie enjoyed, and he had been characterized as lazy since his first days in the territory. Nancy gave Charlie a reason to discipline himself. Over the next few years, he developed a work pattern that would have been the envy of many present-day artists.

Nancy's first major decision—that they must move to Great Falls, where a greater audience for his art might be expected—was only partially successful. They lived in a neat but very modest house at the east end of town. It was often a long time between sales, and undoubtedly the occasional gift from rancher friends of a couple of chickens or a quarter of fresh game was most welcome. Charlie expressed his thanks for these gifts in charmingly illustrated letters; most were lovingly kept by the recipients down through the years.

The first visit from Charles Silas Russell, who came from St. Louis to see just what was going on with his son, proved to be a bonanza. Nancy, utilizing all her charms and genuinely anxious to make a good impression on this very successful businessman, completely captivated Charlie's father. He provided the funds for Nancy and Charlie to purchase a couple of lots in what Nancy considered the nicest residential area of the less-than-

fifteen-year-old city of Great Falls. Charlie had inherited a modest sum on his mother's death some five years previously, and this made it possible to build a thoroughly respectable home on Fourth Avenue North. A stable on the alley provided a good place for Neenah, who had by now taken Monte's place. (Charlie boarded Monte on some land at the edge of town, as he would do with all of his horses when they got too old to be ridden.) There was a coop and run for chickens, and by 1903, a log cabin studio, built on a vacant lot to the west of their home; the studio was constructed by a friend, George Calvert, from surplus telephone poles. It provided Charlie not only with a place to paint but also with a place to entertain his old friends from horse-wrangling days.

Soon, they bought a cabin, which they called Bull Head Lodge, at Lake MacDonald; this provided them with a place to spend the warm summer days and fulfilled Charlie's desire for a wilderness spot such as he had known with Jake Hoover. By that time, of course, Nancy had been managing their lives for quite some time. Charles Shatzlien, their first dealer and a Butte frame and art-supply store owner, had told them, "Charlie, I can get more for one of your paintings than you ask for six of them. Why don't you let Nancy handle the business affairs, and you just paint?" Nancy knew they had to get to where the business of art really was: New York City. In the fall of 1903, the first trip to the "Big Camp" was made. They returned almost annually for the next fifteen years.

These were good years. Nancy asked and got ever-increasing prices for Charlie's work, until she was widely known by New York art dealers as "Nancy the Robber." She negotiated a contract with Brown and Bigelow, the St. Paul calendar company, that gave the company the reproduction rights to six paintings a year for five hundred dollars each. A guarantee of three thousand dollars a year in 1908 gave them a sense of security that few artists enjoyed.

A major one-man show, "The West That Has Passed," was held in 1911 at the Folsum Galleries on Fifth Avenue, and in connection with that exhibition, an extensive article on Charlie was printed in the *New York Times*. Nancy, who strove mightily to achieve a genteel social manner and behavior, was not above creating publicity wherever she could. That same year, Charlie received the commission from the state of Montana for his largest-ever painting, a mural entitled *Lewis and Clark Meeting Indians at Ross' Hole*. It is generally conceded to be his masterpiece.

In September of 1912, Charlie and Nancy attended the first Calgary Stampede as the guests of Guy Weadick, promoter of the rodeo and Wild West Show. Nancy arranged a showing of Charlie's paintings, which elicited enthusiastic responses from a number of titled Englishmen in attendance, including Sir Henry Pellat, who purchased five.

21

This was not Charlie's first international exhibition. In 1906, he had a similar showing of his work in Mexico City. Nor was it his last, for in 1914, a major exhibition was mounted at the Dore Galleries, New Bond Street, London. Here, as wherever they traveled, the Russells were widely entertained by high-ranking social figures. For all their lack of formal schooling and sophisticated etiquette, Charlie and Nancy endeared themselves to a broad spectrum of society. They both had, to an extraordinary degree, a personal charisma that was contagious; Charlie, with his great fund of humorous stories, was as appealing to

bluebloods as he was to his cowboy friends in Montana.

In 1902, Charlie met William S. Hart, one of the outstanding theatrical personalities of that era, at the railroad station in Great Falls. From that time on, he established lasting friendships with the top performers of the day. He and Will Rogers met during the first trips to New York, and thereafter were devoted admirers of each other's talent. Will was probably responsible for introducing Charlie to the inner circle of Hollywood's western stars, and by 1919, Charlie and Nancy were spending a major portion of each winter in Southern California. Charlie made many satirical and pithy remarks about the flora, fauna, and mostly the come-latelies of California, but he enjoyed visiting with such friends as Harry Carey, Tom Mix, Rogers and Hart, and Ed Borein. Nancy, of course, found new patrons for Charlie's work, and it was here that she achieved the first ten-thousand-dollar sale and the final commission of thirty thousand dollars for the murals in the library of Edward Dohney.

There was a bittersweet quality about the last years of Charlie Russell's life. In the midst of a success that few American artists had ever known, he suddenly was beset with physical ailments. First, he had to have all of his teeth pulled. Then, intense bouts of intestinal problems struck with force. In 1923, sciatica prevented him from painting for months. Underlying all these wearisome but not life-threatening problems, something of real significance was eating away at his strength. His beloved Montana, his land of limitless skies, towering mountains, and rolling prairies, had for years been shortchanging him. Although rich in so many highly desired minerals—gold and silver and brilliant blue sapphires—Montana's soil and water were devoid of iodine. A goiter developed and slowly began to squeeze the very breath from him. In 1923, he was having all his shirts custom-made to accommodate an 18½-inch neck measurement.

Like many of his generation, Charlie was deathly afraid of the surgeon's knife. Even then, the removal of a goiter was a fairly uncomplicated operation, but he avoided it, month after month. When he finally consented to the surgery on June 26, 1926, the operation went so well and his recovery was so rapid that Charlie must have had many secret regrets for not submitting to it much earlier. But he had put it off for too long; the doctors told him that his heart had been terribly affected and that he had only six months, perhaps a bit more, to live.

"Don't tell Nancy," Charlie begged the doctors.

"Don't tell Charlie," Nancy requested when the doctors passed on the verdict.

22 The two returned to Montana and almost immediately went up to Bull Head Lodge, a place not very convenient to doctors or medical support but in the midst of a land guaranteed to brighten Charlie's spirits, both mental and physical. It was here that he wrote thank-you notes to a myriad of friends who had sent prayers, good wishes, and floral arrangements while he was in the hospital. He wrote to Miss Isabel Brown, thanking her for her good wishes, and he wrote his dear friend and next-door neighbor, Josephine Trigg, on the occasion of her mid-August birthday. And it was here that Charlie Russell probably made peace with himself.

Mid-October in Great Falls was chilly and overcast. In late September, the leaves had turned golden and fallen in great drifts. Early mornings, a glaze of ice covered the streets. Winter was rapidly approaching.

On Saturday, October 23, Charlie and a newspaper-editor friend went to Charlie Beal's studio after lunch to "jaw awhile." Beal was a young sculptor who had moved to Great Falls with the single hope of standing in the shadow of his hero, Charles Marion Russell, hoping to have some time with him, some advice from this artist whom he admired above all others. Beal later recalled a long, lazy Saturday afternoon. The three talked about art, about the old times when "regular men" rode across open land, before fences, or nesters, or tumbleweeds. "Backtracking," Charlie called it.

The next night, Sunday, October 24, 1926, at 11:30 P.M., Charlie suffered a massive heart attack. As he died, Nancy held his hand while Dr. Edwin and Christoph Keller, the Episcopal minister, helplessly hovered nearby.

He left behind a body of work seldom matched. Over forty-five hundred pieces have been accounted for: great oils; exciting and often charming watercolors; crisp and effective pen drawings; casual, fluid pencil sketches; and more than two hundred fifty pieces of sculpture. He left some fifty stories that he had written and published, hundreds of illustrated letters, and innumerable books that remain desirable primarily because of his illustrations. He left hundreds of devoted friends and thousands more who had never known him personally but who took him into their lives and added to the folklore that grew up around him even while he lived. He left a philosophy that reflects much of the mainstream thinking in western America today. In his writings, he displayed a gentle humor and a passionate appreciation of the broad lands of the West and of a way of life that had long passed into history. Finally, Charlie Russell left a lifelong pattern of not judging his fellow man—too harshly.

Does such a man ever really die?

NOTES

1. The Niedringhaus brothers had developed a highly successful hardware business in St. Louis, Missouri. They were holders of patents covering the newly manufactured blue-and-white kitchenware. The universal popularity of this attractive, but inexpensive, graniteware ensured their fortune, which they invested in Texas longhorns and trailed to the northwest section of the Musselshell country in mid-Montana. The steers carried the N–N brand and are easily identifiable in a number of Russell oils and watercolors.

2. One other Jaramillo daughter married Kit Carson.

3. *Montana, A State Guide Book.* New York: Viking Press, 1939.

4. The plan to ship the herd from Miles City had to be revised, since the railroad had not been completed into that eastern Montana town in the fall of 1881. Plans were switched, and the first Judith Basin drive trailed the herd all the way to Glendive. It became known as "the Long Trail Drive."

5. The description of this first commission (since lost) is found in letters from Laura Edgar Wittemore in the James Rankin papers.

6. A chinook is a warm, usually southwestern, wind that can effectively melt ice and snow quickly, allowing the cattle to reach grass.

7. A cowboy's sack or bag in which he carried all of his personal possessions.

8. A Southern California businessman who, in the 1940s and 1950s, bought and sold a number of Russell artworks.

A TOUR OF CURIOSITY AND AMUSEMENT

A TOUR OF CURIOSITY AND AMUSEMENT

IN THE SPRING OF 1846, FRANCIS PARKMAN, SCION OF A PROMINENT BOSTON family and recently graduated from Harvard, set out on "tour of curiosity and amusement to the Rocky Mountains." Despite dilettantish overtones, the purpose of Parkman's expedition was of a more serious nature. Having had an interest in Indians for as long as he could remember, Parkman had, by his sophomore year, determined to spend his life writing the history of "the old French war."

Scholarly research would not suffice for the budding historian. He wished to observe firsthand the life and character of the Indians. Despite a rather delicate constitution, aggravated perhaps by a degree of hypochondria, Parkman, with his first cousin, Quincy Adams Shaw, set out on a demanding and sometimes foolhardy adventure. The great triangular trip would take him from St. Louis northwest across Kansas and southwestern Nebraska into Wyoming, returning southward through Colorado along the eastern foothills of the Rockies to Bent's Fort on the Arkansas and thence back to St. Louis. Outward-bound, the group traveled on the Oregon Trail; on their return to the East they followed the Santa Fe Trail.

Parkman outfitted in St. Louis, acquiring as a guide the services of Henry Chatillon, a fortuitous addition to the expedition; he hired Antonio Deslauriers as muleteer and general lackey. Although illiterate, Chatillon was universally characterized as a superb hunter, extraordinarily experienced in Rocky Mountain life and "gentlemanly in all his relations." He had the extra advantage of being married to Bear Robe, daughter of Bull Bear, principal chief of the Oglala Sioux, the Indians Parkman wished to visit and observe. His association with Chatillon assured Parkman of entrée into the Sioux villages.

At Westport, Parkman's small group allied themselves with a similar-sized group of travelers, English adventurers who were infinitely more acceptable, socially, to the young Boston Brahmin than the ragtag emigrants who made up most of the westward-bound

horde spilling out across the prairies during that tumultuous summer.

Although the group set out with some concern of being attacked by the Indians through whose territory they would be traveling, the trip was marked by nothing more disruptive than lost trails, horses that slipped their hobbles and wandered off, and young aristocrats subjected to the raucous and ill-bred manners of the emigrants they encountered on the trail.

Reaching Fort Laramie on June 15, Parkman "rejoiced to learn" that the Oglalas, under the leadership of Whirlwind, were gathering in the vicinity for the purpose of mounting an attack on a band of Snake Indians who, the previous year, had been responsible for killing ten young Oglala warriors led by Whirlwind's son.

With little regard for his safety and in spite of a debilitating attack of dysentery, Parkman intended to join the tribal gathering, move into one of the lodges, and thereby become "acquainted with the Indian character."

The adventurous, if naive, Bostonian did not reckon with the vagaries of the Indian's nature. Before Parkman could complete his arrangements, the Oglalas had second thoughts about raising a war party and, deciding they needed new skins and poles for their lodges, went off to hunt for buffalo cows!

Accompanied by a new recruit, Raymond, Parkman left the rest of his party at Fort Laramie and went searching for the Indian village. If he had to forego the pleasures of observing the ceremonies and dances in preparation for war, he would certainly not lose the opportunity of hunting with the Indians.

For two weeks, moving across hot and arid prairies or in the rugged mountains of the Laramie Range, Parkman lived with the tribe. Although weakened by dysentery, his determination to know the Indian could not be denied. The chapters of his journal dealing with this period of the expedition contain some of the most detailed and graphic accounts of daily life in an Indian camp to be found in western American literature, and they must have been the source of inspiration for numerous artists in subsequent years, including Charles M. Russell.

While the eastern aristocrat observed, he also slowly formed the opinion that the Indians were, after all, savages: ignorant, indolent, and (most of them) lacking in the "moral fiber" so treasured by his Puritan forebears.

All the while Parkman rode over hill and dale with the Indians or stayed in camp fretting over his "irresistable laziness," a contagion he ascribed to the Indians' way of life, history was being made throughout the West. Kearny's Army of the West was at Bent's Fort outfitting for the assault on Santa Fe; Fremont was holed up in Oregon waiting to pounce on northern California; members of what would become known as the Donner Party were reorganizing at Fort Laramie; and mountain men whose names were synonymous with the color, adventure, and romance of this epochal period either crossed trails with Parkman or shared a pipe with him.

Yet the great significance of this fateful summer seemed to have escaped Parkman's attention. Dr. E. M. Feltskog points out, "When Parkman reached Westport toward the end of September in 1846, he had ridden over more than two thousand miles of prairies, deserts, and mountains and had seen or heard of almost all the heroic figures in the year

that made the Great West at last and forever American. But little of this hard-won experience appears in *The Oregon Trail;* the book is notably lacking in analysis" The noted author-historian, Bernard DeVoto, lamented, "It was Parkman's fortune to witness and take part in one of the greatest national experiences, at the moment and site of its occurrence. It is our misfortune that he did not understand the smallest part of it." DeVoto lauds Parkman for producing "one of the exuberant masterpieces of American literature" but states, "it ought instead to have produced a key work of American history."

Dr. Feltskog and DeVoto, along with historian Mason Wade, apparently concluded that the snobbishness, provincialism, as well as the Puritanical orientation of the Boston Brahmin precluded any acceptance of or understanding for the crude and coarse emigrants and volunteers of the westward movement.

For all of Parkman's obtuseness, DeVoto pays a genuine tribute to him, saying, "The Puritan took with him a quiet valor which has not been outmatched among literary folk or in the history of the West."

Parkman had an interesting analysis of his own personality. He wrote that he was "as fond of hardships as he was vain of enduring them."

And despite his Puritanism, inherited from a long line of renowned clerics, Parkman was a romantic. His ideal of manhood was by his own admission "a little medieval." This was a significant part of Charles Russell's own character, as well, and may account for the admiration the cowboy artist held for the effete Easterner.

A BIBLIOGRAPHIC TREASURE

The history of Francis Parkman's *The Oregon Trail* is both complex and interesting. With the exception of some literary classics, only a few other American publications have remained in print for one hundred thirty-seven years.

Parkman's journals of this western expedition were first published in twenty-one installments in the *Knickerbocker Magazine* beginning in February 1847 and continuing through February 1849, printed under the title *The Oregon Trail. Or a Summer's Journey Out of Bounds. By A Bostonian.* In March 1849, George P. Putnam published the book as *The California and Oregon Trail: Being Sketches of Prairie and Rocky Mountain Life.* In 1852, Putnam again published it as *Prairie and Rocky Mountain Life; Or, The California and Oregon Trail.*[1]

In 1872, Parkman made extensive revisions in the text, and Little, Brown and Company published it as *The Oregon Trail,* and it has remained in print under that title to the present day.

In 1892, Little, Brown and Company decided to bring out an illustrated edition, and they commissioned Frederic Remington to do the art work.[2] At that time the foremost illustrator of western material in the country, Remington produced ten full-page illustrations and sixty-seven smaller sketches for the edition, which Parkman, for the final time, revised and to which he added a new, and rather elegiac, preface.[3] Parkman died the following year, and his passing elicited an outpouring of praise from his peers for his extraordinary contribution to American history and literature. In 1898, Little, Brown and Company planned a twenty-volume edition of Parkman's entire works, with *The Oregon*

Trail as volumes nineteen and twenty.[4]

In connection with this publication, an "Edition de Luxe" of eight copies, bound in morocco, was offered. Intricately embossed in gold leaf, the covers were decorated with a portrait of the young Francis Parkman.

Sometime late in 1920 or very early in 1921, the number three copy of this edition came into the possession of a Southern California oil man, William Armstrong. Mr. Armstrong was the first patron of Charles Russell to pay ten thousand dollars for one of the cowboy artist's oil paintings. That piece, *Salute to the Robe Trade* (now owned by the Gilcrease Institute, Tulsa) was, according to Russell experts, one of the artist's finer works. At a dinner party at Armstrong's home early in 1921, the collector, naturally proud of the acquisition of Parkman's deluxe edition, showed the *Oregon Trail* volumes to Russell. Expressing an interest in the books, Russell asked to borrow them. Armstrong, a devoted fan of the artist, readily turned the two volumes over to him.

Some weeks later, Armstrong became worried about the exceedingly valuable volumes and called Russell, saying somewhat huffily, "Charlie, where are my Parkman books?" Charlie assured Armstrong he was just getting ready to return them. The next day, the cowboy artist laid the two volumes on Armstrong's desk, saying, "I thought you might like to see how they *should* have been illustrated."[5] Inside were fifty watercolor sketches, lovingly superimposed on Parkman's text. Armstrong, of course, forgave Russell for keeping the books so long. They were now even greater treasures.

The Depression brought hard times to Armstrong. He not only was forced to sell the Parkman books, he also sold the magnificent bronze, *Meat For Wild Men,* one of only four copies of Russell's largest and most important sculpture.

No one alive today knows who bought the deluxe edition of *The Oregon Trail* from Armstrong sometime in the mid-to-late thirties. The books went unaccounted for a dozen years or more. A few Russell collectors around the country knew of them but did not know where they were. Fred Renner, who spent more than fifty years searching out all of Russell's works, visited with Mrs. Armstrong in the early fifties, but even she didn't know the fate of this very special edition. Renner does not remember the exact date, but sometime in the 1950s he received a call from his good friend, Walter Latendorf, one of the country's most knowledgeable rare book dealers, whose New York City establishment was a gathering place for bibliophiles across the country.

"Fred," he said excitedly, "I've got the Armstrong edition of the Parkman books. I'm going to publish them; they're too great not to be shared. Can you come up and see them? You'll love them!"

One week later, when Renner walked into Latendorf's shop, he thought his host looked a trifle chagrined.

"Where are the Armstrong books?" Renner asked.

"I haven't got them," Latendorf admitted, and then the story came out.

"Last Saturday, a rainy, miserable day, I was here by myself," Latendorf explained. "In came a little old lady in a nondescript raincoat and carrying a dripping umbrella. She wandered around for awhile and then, coming over to my desk, she asked, 'Don't you have

anything really special?' Well, Fred, you know I didn't intend to sell those books; I wanted to publish them so lots of people could enjoy those beautiful watercolor sketches. But I was very proud of them, and I got them out and handed them over to her. She took them over in a corner and carefully went through them page by page. Half an hour later, she came to my desk and asked, 'How much do you want for them, Mr. Latendorf?' Not intending to sell them, I thought I'd quote a price so high that she couldn't possibly pay it . . . after all, Fred, she didn't look like she could come up with two hundred dollars. So I took a deep breath and said, 'They're twelve thousand dollars, Ma'am.' And what did she do? Just took out her checkbook and wrote out the amount!"

And so Miss Clara Peck, collector extraordinary, a woman with superb taste and the funds to pay for her carefully selected acquisitions, became the owner of the Armstrong edition of Parkman's works, including the two volumes Charlie Russell had extra-illustrated with fifty watercolor sketches.

For almost thirty years the volumes were carefully sequestered in Miss Peck's apartment in the Hotel Pierre. In the last years of her life, Bob Rockwell became her friend, visiting her whenever he could get to New York City. They shared a genuine love and admiration for Russell's works and for the art, history, and legends of the West.

In her will, Miss Peck left to the Rockwell Museum this remarkable publication. It is a manifestation of Charlie Russell's abiding love for the Old West. In a letter he sent to Armstrong in April 1921 he says,

> To make sketches in Francis Parkman's books has been a pleasure for me. When I read his work I seem to live in his time and travel the trails with him.

It is also a remarkable testimony to the insightful taste of a little old lady with a dripping umbrella!

NOTES

1. The author owes an immense debt of gratitude to Dr. E. N. Feltskog, University of Wisconsin, Madison. His splendidly authoritative text on Parkman's *The Oregon Trail* has been invaluable in preparing the material for the Parkman section of this catalogue. In his text (Francis Parkman, *The Oregon Trail*, ed. E. N. Feltskog. Madison, Milwaukee, London: University of Wisconsin Press, 1969), Dr. Feltskog collates all nine editions of *The Oregon Trail* published during Parkman's lifetime, adding richly to the reader's appreciation of the Bostonian's contribution to American history.

2. Other editions of *The Oregon Trail* have been illustrated by such diverse artists as Thomas Hart Benton, N. C. Wyeth, and Maynard Dixon.

3. In publishing the 1898 edition of the complete works of Parkman, Little, Brown and Company, for some unknown reason, resorted to the 1872 plates, thereby eliminating the sixty-seven small Remington sketches from the edition. Naturally, this gave Russell space to paint his own.

4. The 1898 version eliminates three of Remington's halftones and adds a portrait of Daniel Boone (whose import to the Parkman text was questionable), listing it as "From the original painting in the possession of the Massachusetts Historical Society."

5. It is apparent that Russell was familiar with both the 1892 version of *The Oregon Trail* containing the Remington sketches scattered throughout, as well as with the 1872 edition (*sans* the sixty-seven illustrations).

Frontier Guardian
Signed lower right, CMR (skull)
2½ x 4½ inches

Charles Russell was far more interested in the natives who inhabited the vast, untamed stretches of the western United States than he was in the emigrants who came hoping to conquer and civilize that seemingly limitless territory. As an introductory illustration for Francis Parkman's journals of his 1846 trip along the Oregon Trail, the artist focuses on the grey wolf, a wily scavenger of rolling plains, uneasily watching the inexorable westward movement of the wagon trains.

The French Hunter
Signed lower right, CMR (skull)
3½ x 3 inches

Unconstrained by the limitations of a commission, Russell illustrated those elements of the journals that appealed to him most. The French hunter, or trapper, the forerunner of a hardy breed of indomitable individualists, adopted the Indian's way of life and was to a significant degree assimilated into their culture, a situation that appealed greatly to Charles Russell. Parkman describes this particular hunter as "a tall strong figure, with a clear blue eye and an open, intelligent face, [who] very well represented that race of restless and intrepid pioneers whose axes and rifles have opened a path from the Alleghanies to the western prairies."

Old Kansas Indian
Signed below, CMR (skull)
2¾ x 1¾ inches

Less than a day's journey west of Westport, while taking a noon stop on the trail, Parkman's party was visited by "an old Kansas Indian—a man of distinction, if one might judge from his dress." The author describes in detail his various adornments. He was invited to share a cup of sweetened water which he pronounced "good!" and proceeded to regale the group with tales of how many Pawnees he had killed.

32

The Old Delaware
Signed lower left, CMR (skull)
3⅛ x 1½ inches

Shortly before reaching Fort Leavenworth, while crossing land occupied by the Delaware Indians, the old Indian rode by and stopped to speak to Parkman's group. He asked Henry Chatillon, "Who's your chief?" The *bourgeois* pointed to the twenty-three-year-old Parkman, whereupon the old Delaware snorted, "No good! Too young!" and rode off.

THE OREGON TRAIL.

CHAPTER I.

THE FRONTIER.

LAST spring, 1846, was a busy season in the city of St. Louis. Not only were emigrants from every part of the country preparing for the journey to Oregon and California, but an unusual number of traders were making ready their wagons and outfits for Santa Fé. The hotels were crowded, and the gunsmiths and saddlers were kept constantly at work in providing arms and equipments for the different parties of travellers. Steamboats were leaving the levee and passing up the Missouri, crowded with passengers on their way to the frontier.

In one of these, the "Radnor," since snagged and lost, my friend and relative, Quincy Adams Shaw, and myself, left St. Louis on the twenty-eighth of April, on a tour of curiosity and amusement to the Rocky Mountains. The boat was loaded until the water broke alternately over her guards. Her upper deck was covered with large wagons of a peculiar form, for the Santa Fé trade, and her hold was

CHAPTER II.

BREAKING THE ICE.

EMERGING from the mud-holes of Westport, we pursued our way for some time along the narrow track, in the checkered sunshine and shadow of the woods, till at length, issuing into the broad light, we left behind us the farthest outskirts of the great forest, that once spread from the western plains to the shore of the Atlantic. Looking over an intervening belt of bushes, we saw the green, ocean-like expanse of prairie, stretching swell beyond swell to

gully, of a species that afterward became but too familiar to us, and here for the space of an hour or more the cart stuck fast.

council was held, in which it was resolved to remain one day at Fort Leavenworth, and on the next to bid a final adieu to the frontier, or, in the phraseology of the region, to "jump off." Our deliberations were conducted by the ruddy light from a distant swell of the prairie where the long dry grass of last summer was on fire.

Plains Woman
Not signed
1¾ x 1¾ inches

The short chapter on Fort Leavenworth is devoid of exciting happenings or outstanding characters. It is interesting that Russell should choose to fill this gap with the portrait of a handsome young Indian woman, who has no relationship to the text.

Kickapoo Indian
Signed CM Russell (skull)
4 x 2½ inches

West of Fort Leavenworth, Parkman and his companions camped at the village of the Kickapoo Indians, bordering on the Missouri River. The young Bostonian termed the natives "unfortunate and self-abandoned." Probably never having seen a Kickapoo Indian and therefore unaware of individualistic facial characteristics, Russell wraps this Indian in the anonymity of a red blanket, a costume most Plains Indians adopted whenever possible.

Into the Unknown
Signed lower right, CMR (skull)
2¼ x 4 inches

Parkman, with his cousin Quincy Adams Shaw, guide and hunter Henry Chatillon, and the muleteer and general camp handyman Deslauriers, joined up with a small group of English adventurers, more for additional support against an Indian attack than for company. Leaving civilization behind at Fort Leavenworth and the Kickapoo Indian village, they headed westward into unknown country on May 23, 1846.

Deslauriers and His Cart
Not signed
2 x 3½ inches

All of the supplies and extra equipment of the party were hauled along in a truncated version of a covered wagon, drawn by one or two mules. Considering the number of miles traversed, the gullys, hills and streams crossed, and the lack of trails much of the way, it speaks well of the abilities of Deslauriers that the small cart held up from Missouri to Fort Laramie, Wyoming Territory, and through the return trip.

CHAPTER III.

FORT LEAVENWORTH.

On the next morning we rode to Fort Leavenworth. Colonel, now General Kearney, to whom I had had the honor of an introduction when at St. Louis, was just arrived, and received us at his quarters with the courtesy habitual to him. Fort Leavenworth is in fact no fort, being without defensive works, except two blockhouses. No rumors of war had as yet disturbed its tranquillity. In the square grassy area, surrounded by barracks and the quarters of the officers, the men were passing and repassing, or

Then, mounting, we rode together to the camp, where everything was in readiness for departure on the morrow.

CHAPTER IV.

"JUMPING OFF."

Our transatlantic companions were well equipped for the journey. They had a wagon drawn by six mules, and crammed with provisions for six months, besides ammunition enough for a regiment; spare rifles and fowling-pieces, ropes and harness, personal baggage, and a miscellaneous assortment of articles, which produced infinite embarrassment. They had also decorated their persons with telescopes and portable compasses, and carried English double-barrelled rifles of sixteen to the pound calibre, slung to their saddles in dragoon fashion.

By sunrise on the twenty-third of May we had breakfasted; the tents were levelled, the animals saddled and harnessed, and all was prepared. "*Avance donc!* get up!" cried Deslauriers to his mule. Wright, our friends' muleteer, after some swearing and lashing, got his insubordinate train in motion, and then the whole party filed from the ground. Thus we bade a long adieu to bed and board, and the principles of Blackstone's Commentaries. The day was a most auspicious one; and yet Shaw and I felt certain misgivings, which in the sequel proved but too well founded. We had just learned that though

CHAPTER V.

THE "BIG BLUE."

The great medley of Oregon and California emigrants at their camps around Independence had heard reports that several additional parties were on the point of setting out from St. Joseph farther to the northward. The prevailing impression was that these were Mormons, twenty-three hundred in number; and a great alarm was excited in consequence. The people of Illinois and Missouri, who composed by far the greater part of the emigrants, have never

empty wagons were easily passed across; and then, each man mounting a horse, we rode through the stream, the stray animals following of their own accord.

CHAPTER VII.
THE BUFFALO.

FOUR days on the Platte, and yet no buffalo! Last year's signs of them were provokingly abundant; and wood being extremely scarce, we found an admirable substitute in the *bois de vache*, which burns like peat, producing no unpleasant effects. The wagons one morning had left the camp; Shaw and I were already on horseback, but Henry Chatillon still sat cross-legged by the dead embers of the fire, playing pensively with the lock of his rifle, while his sturdy Wyandot pony stood quietly behind him, looking over his head. At last he got up, patted the neck of the pony (which, from an exaggerated appreciation of his merits, he had christened "Five Hundred Dollar"), and then mounted, with a melancholy air.

"What is it, Henry?"

"Ah, I feel lonesome; I never been here before but I see away yonder over the buttes, and down there on the prairie, black — all black with buffalo."

In the afternoon he and I left the party in search of an antelope, until, at the distance of a mile or two on the right, the tall white wagons and the little

VOL. I. — 6

CHAPTER VI.
THE PLATTE AND THE DESERT.

WE were now at the end of our solitary journeyings along the St. Joseph trail. On the evening of the twenty-third of May we encamped near its junction with the old legitimate trail of the Oregon emigrants. We had ridden long that afternoon, trying in vain to find wood and water, until at length we saw the sunset sky reflected from a pool encircled by bushes and rocks. The water lay in the bottom of a hollow, the smooth prairie gracefully rising in ocean-like swells on every side. We pitched our tents by it; not, however, before the keen eye of Henry Chatillon had discerned some unusual object upon the faintly-defined outline of the distant swell. But in the moist, hazy atmosphere of the evening, nothing could be clearly distinguished. As we lay around the fire after supper, a low and distant sound, strange enough amid the loneliness of the prairie, reached our ears, — peals of laughter, and the faint voices of men and women. For eight days we had not encountered a human being, and this singular

walked back to their wagons, and the captain betook himself pensively to his tent. Shaw and I followed his example.

Deslauriers, the Muleteer
Not signed
1½ x 1¾ inches

A Canadian, Deslauriers' primary loyalty and obedience lay with his *bourgeois,* Henry Chatillon, but Parkman often acknowledged throughout his journal the resourcefulness and multitalents of the muleteer. This, despite the French-Canadian's frequent resort to a favorite phrase, "Sacre enfant de garce!" bold language to use in the presence of the Bostonian.

Pawnees at the Platte
Signed lower left, CMR (skull)
2½ x 4 inches

The principal encounter Parkman relates in Chapter Six in great detail is with a large group of discontented emigrants heading for Oregon and California. Despite this, Russell chooses to illustrate a brief and very casual mention of a line of Pawnees returning from a hunt across the prairies.

Black With Buffalo
Signed lower right, CM Russell (skull)
2½ x 4½ inches

Four days' journey along the Platte brought the group into prime buffalo country. Henry Chatillon remarked to his companions, "I never been here before but I see away yonder over the buttes—black—all black with buffalo." Henry, as usual, was successful on the hunt, bringing down two fat cows.

Henry Chatillon Takes on the Herd
Signed CM Russell (skull) 1921
4½ x 4¼ inches

37

Parkman, early in his journals, acknowledged his *bourgeois'* ability with a rifle, stating, "As a hunter, he had but one rival in the whole region, a man named Simoneau, with whom, to the honor of both of them, he was on terms of closest friendship."

CHAPTER VIII.

TAKING FRENCH LEAVE.

ON the eighth of June, at eleven o'clock, we reached the South Fork of the Platte, at the usual fording-place. For league upon league the desert uniformity of the prospect was almost unbroken; the hills were dotted with little tufts of shrivelled grass, but betwixt these the white sand was glaring in the sun; and the channel of the river, almost on a level with the plain, was but one great sand-bed, about half a mile wide. It was covered with water, but so scantily that the bottom was scarcely hidden; for, wide as it is, the average depth of the Platte does not at this point exceed a foot and a half. Stopping near its bank, we gathered *bois de vache*, and made a meal of buffalo-meat. Far off, on the other side, was a green meadow, where we could see the white tents and wagons of an emigrant camp; and just opposite to us we could discern a group of men and animals at the water's edge. Four or five horsemen soon entered the river, and in ten minutes had waded across and clambered up the loose sand-bank. They were ill-looking fellows, thin and swarthy, with careworn anxious faces, and lips rigidly compressed.

This done, we took our leave without farther ceremony, knocked at the gate of the fort, and, after making ourselves known, were admitted.

CHAPTER IX.

SCENES AT FORT LARAMIE.

LOOKING back, after the expiration of a year, upon Fort Laramie and its inmates, they seem less like a reality than like some fanciful picture of the olden time; so different was the scene from any which this tamer side of the world can present. Tall Indians, enveloped in their white buffalo-robes, were striding across the area or reclining at full length on the low

CHAPTER X.

THE WAR-PARTIES.

THE summer of 1846 was a season of warlike excitement among all the western bands of the Dahcotah. In 1845 they encountered great reverses. Many war-parties had been sent out; some of them had been cut off, and others had returned broken and disheartened; so that the whole nation was in mourning. Among the rest, ten warriors had gone to the Snake country, led by the son of a prominent Ogillallah chief, called The Whirlwind. In passing over Laramie Plains they encountered a superior number of their enemies, were surrounded, and killed to a man. Having performed this exploit, the Snakes became alarmed, dreading the resentment of the Dahcotah; and they hastened therefore to signify their wish for peace by sending the scalp of the slain partisan, with a small parcel of tobacco attached, to his tribesmen and relations. They had employed old Vaskiss, the trader, as their messenger, and the scalp was the same that hung in our room at the fort. But The Whirlwind proved inexorable. Though his character hardly corresponds with his name, he is nevertheless an Indian, and hates the Snakes with

Old Smoke's Favorite Squaw
Signed lower left, CMR (skull)
2¾ x 2½ inches

Although the chapter is replete with interesting characters and events, it is not surprising that Russell chose to illustrate Old Smoke's favorite squaw. Parkman, with uncharacteristic approval, describes the young woman's attractive appearance, enhanced by whitened and fringed garments and tinkling ornaments. She was, moreover, entrusted with and honored by the assignment of carrying her husband's lance, war shield, and pipe. The description would have appealed to Russell, who seldom passed an opportunity to paint attractive Indian women.

Dakota Warrior
Signed below, CMR (skull)
3 x 1¾ inches

Moving along the Platte, east of Scottsbluff, the Parkman party was intercepted by a Dakota warrior bringing an invitation to join Old Smoke's lodge, a few miles distant. Parkman notes he was "a good speciman of a Dakota warrior . . . lithely and gracefully, yet strongly proportional . . . ornamented by a talisman, a war eagle wingbone in his long hair and from the back of his head a line of glittering brass plates, an ornament in 'high vogue with the Dakota' and for which they paid the traders a most extravagant price."

Trader at Fort Laramie
Signed lower right, CMR (skull)
2½ x 3¾ inches

Fort Laramie, in what is now southeastern Wyoming, was established by the American Fur Company and, according to Parkman, "well-nigh monopolized the Indian trade of this region." It was the gathering place of emigrants, mountain men, trappers, French *engagés,* and several bands of Teton Sioux Indians.

The Horse
Not signed
2¼ x 2 inches

In Parkman's eyes, the Dakota Indian, The Horse, was an "arrant dandy . . . face painted with vermilion . . . on his head fluttered the tail of a prairie cock" and he carried a "dragoon sword, solely for display." But when the Indian rode into Fort Laramie, Parkman notes he was "bestriding his yellow horse with an air of extreme dignity." Russell obviously preferred the latter characteristic rather than Parkman's first assessment of the Indian.

Medallion
Not signed
2¾ x ½ inches

The scrap of cloth or painted leather, stretched on a willow circle, adorned by fringe or a scalplock, was a favorite ornamentation of the Plains Indians.

The Dakota War Party
Signed lower left, CMR (skull)
3½ x 4 inches

The summer of 1846 was marked by much unrest among the Indian tribes of the northern Plains. Ten warriors, led by the son of the prominent Oglala chief, Whirlwind, had gone into the Snake country and were slaughtered to a man. The chief, preparing for revenge, sent word to all Dakota within three hundred miles to gather at La Bonte's camp. Parkman was delighted to receive this news and hoped to join the gathering, since his purpose for the trip west was to "study the Indian character" and he felt ceremonies preparing for intertribal war would reveal significant aspects of their way of life.

Whirlwind's Camp
Signed lower right, CMR (skull)
2½ x 4½ inches

In this camp, Parkman became friends with the young warrior, Mahto-Tatonka, brother of Henry Chatillon's squaw—a circumstance that proved advantageous to the Bostonian and his party.

Le Borgne
Not signed
3¼ x 1½ inches

Uncle of Mahto-Tatonka, Parkman characterized Le Borgne as "the Nestor of his tribe." Legend proposed that as a young man seeking his special vision, an antelope (the peace-spirit of the Oglala) appeared to him, advising him that a life of tranquillity was marked for him. Thereafter, the old man shunned war and "devoted himself to the labors of peace."

A Character of the Plains
Signed lower left, CMR (skull)
2¼ x 2 inches

40

The portrait probably represents Antoine Reynal, an Indian trader operating out of Fort Bernard (not a military post) a few miles east of Fort Laramie. Upon deciding to attach themselves to Whirlwind's camp, Parkman's group hired Reynal as general camp helper.

for the service of her spirit; for the woman was lame, and could not travel on foot over the dismal prairies to the villages of the dead. Food, too, was provided, and household implements, for her use upon this last journey.

Henry left her to the care of her relatives, and came immediately with Shaw to the camp. It was some time before he entirely recovered from his dejection.

CHAPTER XI.
SCENES AT THE CAMP.

REYNAL heard guns fired one day, at the distance of a mile or two from the camp. He grew nervous instantly. Visions of Crow war-parties began to haunt his imagination; and when we returned (for we were all absent), he renewed his complaints about being left alone with the Canadians and the squaw. The day after, the cause of the alarm appeared. Four trappers, called Morin, Saraphin, Rouleau, and Gingras, came to our camp and joined us. They it was who fired the guns and disturbed the dreams of our confederate Reynal. They soon encamped by our side. Their rifles, dingy and battered with hard service, rested with ours against the old tree; their strong rude saddles, their buffalo-robes, their traps, and the few rough and simple articles of their travelling equipment were piled near our tent. Their mountain-horses were turned to graze in the meadow among our own; and the men themselves, no less rough and hardy, used to lie half the day in the shade of our tree, lolling on the grass, lazily smoking, and telling stories of their adventures; and I defy the annals of chivalry to furnish the record of a life more

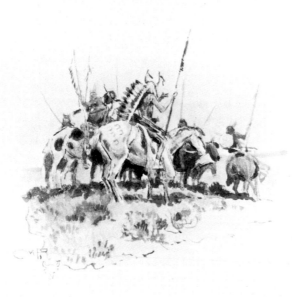

hidden recesses, and explore the chasms and precipices, black torrents and silent forests, that I fancied were concealed there.

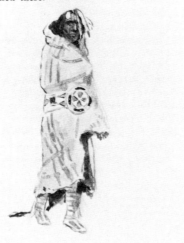

CHAPTER XII.
ILL-LUCK.

A CANADIAN came from Fort Laramie, and brought a curious piece of intelligence. A trapper, fresh from the mountains, had become enamoured of a Missouri damsel belonging to a family who with other emigrants had been for some days encamped in the neighborhood of the fort. If bravery be the most potent charm to win the favor of the fair, then no wooer could be more irresistible than a Rocky Mountain trapper. In the present instance, the suit was not urged in vain. The lovers concerted a scheme,

Shaw lashed his horse and galloped forward. I, though much more vexed than he, was not strong enough to adopt this convenient vent to my feelings; so I followed at a quiet pace. We rode up to a solitary old tree, which seemed the only place fit for encampment. Half its branches were dead, and the rest were so scantily furnished with leaves that they cast but a meagre and wretched shade. We threw down our saddles in the strip of shadow cast by the old twisted trunk, and sat down upon them. In silent indignation we remained smoking for an hour or more, shifting our saddles with the shifting shadow, for the sun was intolerably hot.

the hills. The rank grass, where it was not trampled down by the buffalo, fairly swept our horses' necks.

Again we found the same execrable barren prairie offering no clew by which to guide our way. As we drew near the hills, an opening appeared, through which the Indians must have gone if they had passed that way at all. Slowly we began to ascend it. I felt the most dreary forebodings of ill-success, when on looking round I could discover neither dent of hoof, nor footprint, nor trace of lodge-pole, though the passage was encumbered by the skulls of buffalo.

CHAPTER XIII.

HUNTING INDIANS.

At last we had reached La Bonté's camp, towards which our eyes had turned so long. Of all weary hours, those that passed between noon and sunset of that day may bear away the palm of exquisite discomfort. I lay under the tree reflecting on what course to pursue, watching the shadows which seemed never to move, and the sun which seemed fixed in the sky, and hoping every moment to see the men and horses of Bisonette emerging from the woods. Shaw and Henry had ridden out on a scouting expedition, and did not return till the sun was setting. There was nothing very cheering in their faces or in the news they brought.

"We have been ten miles from here," said Shaw. "We climbed the highest butte we could find, and could not see a buffalo or an Indian; nothing but

I could distinguish a few dark spots on the prairie, along the bank of the stream.

"Buffalo!" said I.

"Horses, by God!" exclaimed Raymond, lashing his mule forward as he spoke. More and more of the plain disclosed itself, and more and more horses appeared, scattered along the river-bank, or feeding in bands over the prairie. Then, standing in a circle by the stream, swarming with their savage inhabitants, we saw, a mile or more off, the tall lodges of the Ogillallah. Never did the heart of wanderer more gladden at the sight of home than did mine at the sight of that Indian camp.

END OF VOL. I.

A Dakota War Dance
Signed lower left, CMR (skull)
3¾ x 3¾ inches

Over a period of days, Whirlwind vacillated on carrying out his threat against the Snake Indians, and his band eventually turned their energies against war and toward the summer hunt for buffalo cow hides. However, the large bands of Teton Sioux he had called together to support him in wreaking vengeance on the Snakes, having camped together along the North Platte, lost no time in mounting an enthusiastic war dance, an event Parkman missed.

A Dakota Beauty
Not signed
2 x 2 inches

Once again, while Parkman expends a long and detailed chapter telling of his search for Whirlwind's constantly moving village, Russell's attention wanders from the text, and he resorts to the face of a Plains beauty for an illustration.

Tomahawk
Not signed
1¾ x 3½ inches

Some variation of the tomahawk, war club, or battle ax has been used as a principal hand weapon since prehistoric times by primitive tribes—and some not so primitive. The Plains Indians decorated the weapon with eagle feathers (and/or painted or beaded leather wrappings), investing it with special powers.

Ogillallah Horse Band
Not signed
1½ x 4 inches

Having spent several days searching through mountains and on the prairies for the Oglala band he wished to join, Parkman was overjoyed to come at last upon the horse herd belonging to Whirlwind's people. He knew the tall lodges of the Dakota would be close by.

THE OREGON TRAIL

CHAPTER XIV

THE OGILLALLAH VILLAGE

THIS is hardly the place for portraying the mental features of the Indians. The same picture, slightly changed in shade and coloring, would serve with very few exceptions for all the tribes north of the Mexican territories. But with this similarity in their modes of thought, the tribes of the lake and ocean shores, of the forests and of the plains, differ greatly in their manner of life. Having been domesticated for several weeks among one of the wildest of the hordes that roam over the remote prairies, I had unusual opportunities of observing them, and flatter myself that a sketch of the scenes that passed daily before my eyes may not be devoid of interest. They were thorough savages. Neither their manners nor their ideas were in the slightest degree modified by contact with civilization. They knew nothing of the power and real character of the white men, and their children would scream in terror when they saw me. Their religion, superstitions, and prejudices were the

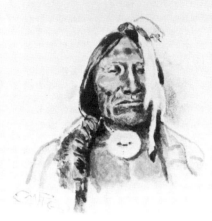

expedition. The other Indian shot at him from the ravine, and then both the bulls ran away at full speed, while half the juvenile population of the village raised a yell and ran after them. The first bull soon stopped, and while the crowd stood looking at him at a respectful distance, he reeled and rolled over on his side. The other, wounded in a less vital part, galloped away to the hills and escaped.

In half an hour it was totally dark. I lay down to sleep, and ill as I was, there was something very animating in the prospect of the general hunt that was to take place on the morrow.

same effect will often follow a series of calamities, or a long run of ill-luck, and Indians have been known to ride into the midst of an enemy's camp, or attack a grizzly bear single-handed, to get rid of a life supposed to lie under the doom of fate.

Thus, after all his fasting, dreaming, and calling upon the Great Spirit, the White Shield's war-party came to nought.

CHAPTER XV

THE HUNTING CAMP.

LONG before daybreak the Indians broke up their camp. The women of Mene-Seela's lodge were as usual among the first that were ready for departure, and I found the old man himself sitting by the embers of the decayed fire, over which he was warming his withered fingers, as the morning was very chill and damp. The preparations for moving were even more confused and disorderly than usual. While some families were leaving the ground, the lodges of others were still standing untouched. At this old Mene-Seela grew impatient, and walking out to the middle of the village, he stood with his robe wrapped close around him, and harangued the people in a loud, sharp voice. Now, he said, when they were on an enemy's hunting-grounds, was not the time to behave

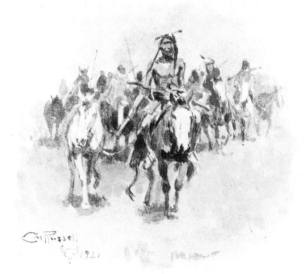

The Ogillallah Village
Signed lower right, CM Russell (skull)
4 x 4½ inches

When Parkman finally located the Indian village, he discovered the camp had been enjoying several days of good hunting, a "surround" having been made each of the past four days on a large bull herd. Russell pictures the camp in the abundance of the summer season with great quantities of meat drying on poles over small, smoking fires.

Big Crow
Signed lower left, CMR (skull)
3 x 2¾ inches

Kongra Tonga, or Big Crow, was the chief in whose lodge Parkman chose to reside during his visit with the Oglalas on their buffalo hunt. According to the Bostonian, ". . . every Indian in the village would have deemed himself honored that white men should give such preference to his hospitality."

A Woman of Mene-Seela's Lodge
Not signed
2 x 4 inches

Mene-Seela, or Red Water, was a famous chief named as a leader among the Brulés by Lewis and Clark. A wise elder of the tribe and the father of Big Crow, he became Parkman's closest Indian friend. The young Easterner stated Mene-Seela was the only Indian with whom he felt safe alone. He also noted that when the village prepared to move, "the women of Mene-Seela's lodge were, as usual, the first ready for departure."

Sparing the Favorites
Signed lower left, CM Russell (skull) 1921
3¾ x 3¾ inches

45

Describing the methods and procedures of the Indian buffalo hunt, Parkman states that the hunters chose inferior horses to ride over the rough country between the campsite and the buffalo range. They led their best horses, saving them for the demanding pursuit of the huge animals. Russell, having few opportunities to witness a buffalo hunt in his lifetime, may have utilized in his most famous paintings details found in Parkman's careful descriptions of the Indians' methods of hunting.

Rouleau, the Trapper
Not signed
2¼ x 2 inches

Rouleau and his companion Saraphin came into the Oglala hunting camp after trapping in the Black Hills. They proposed to go into the Medicine Bow mountains, an area occupied by the Arapahoes, who were at that time threatening to kill any whites who invaded their territory. Despite Mene-Seela's admonitions not to make the trip, the two trappers, laughing at the danger, rode off. Parkman states, "It was the last time I saw them."

Rouleau and Saraphin Depart
Signed lower left, CM Russell (skull) 1921
3½ x 4 inches

Parkman wrote at length of the incongruities of the trapper's life. When on hunting expeditions, the mountain men were subject to danger, deprivation, wild lonely country, and excessive toil. Yet, in Parkman's words, "he continued to follow his perilous calling." This declaration of independence surely impressed Charles Russell, since on numerous occasions he found inspiration in the trapper's lifestyle and painted him as a free spirit.

Hail-Storm
Signed lower left, CMR (skull)
2 x 1¼ inches

The younger brother of The Horse, Hailstorm evolved from neophyte to full-fledged hunter during the period Parkman was associated with him. The Bostonian noted with approbation his development in the hunt and subsequent successes with the young ladies of the camp.

In the Laramie Range
Signed lower left, CMR (skull)
3¼ x 4¼ inches

Throughout much of the journal, Parkman makes many references to the Black Hills (a land area in southwest South Dakota), an area he must have had knowledge of prior to his departure west from St. Louis. But Parkman's group never traveled into the Black Hills or came sufficiently close to see them even at a distance; for the most part, they crossed the Laramie Range.

Bighorn Sheep
Signed lower left, CMR (skull)
2¾ x 4 inches

When the Indian camp moved to higher ground to secure new lodge poles for their tipis, Parkman and his assistant, Raymond, climbed into the mountains hoping to find game to replenish their supplies. He found only the hoofprints of the bighorn sheep.

CHAPTER XVI.

THE TRAPPERS.

In speaking of the Indians, I have almost forgotten two bold adventurers of another race, the trappers Rouleau and Saraphin. These men were bent on a hazardous enterprise. They were on their way to the country ranged by the Arapahoes, a day's journey west of our camp. These Arapahoes, of whom Shaw and I afterwards fell in with a large number, are ferocious savages, who of late had declared themselves enemies to the whites, and threatened death to the first who should venture within their territory. The occasion of the declaration was as follows: —

In the preceding spring, 1845, Colonel Kearney left Fort Leavenworth with several companies of dragoons, marched to Fort Laramie, passed along the foot of the mountains to Bent's Fort, and then, turning eastward again, returned to the point whence he set out. While at Fort Laramie, he sent a part of his command as far westward as Sweetwater, while he himself remained at the fort, and despatched messages to the surrounding Indians to meet him there in council. Then for the first time the tribes of that vicinity saw

whole night the awful chorus of the wolves would resound from the frozen mountains around them, yet within their massive walls of logs they would lie in careless ease before the blazing fire, and in the morning shoot the elk and deer from their very door.

the purpose, and thus can exercise a degree of authority which no one else in the village would dare to assume. While very few Ogillallah chiefs could venture without risk of their lives to strike or lay hands upon the meanest of their people, the "soldiers," in the discharge of their appropriate functions, have full license to make use of these and similar acts of coercion.

CHAPTER XVII.

THE BLACK HILLS.

We travelled eastward for two days, and then the gloomy ridges of the Black Hills rose up before us. The village passed along for some miles beneath their declivities, trailing out to a great length over the arid prairie, or winding among small detached hills of distorted shapes. Turning sharply to the left, we entered a wide defile of the mountains, down the bottom of which a brook came winding, lined with tall grass and dense copses, amid which were hidden many beaver dams and lodges. We passed along between two lines of high precipices and rocks piled in disorder one upon another, with scarcely a tree, a bush, or a clump of grass. The restless Indian boys wandered along their edges and clambered up and down their rugged sides, and sometimes a group of them would stand on the verge of a cliff and look down on the procession as it passed beneath. As we advanced, the passage grew more narrow; then it suddenly expanded into a round grassy meadow, completely encompassed by mountains; and here the families stopped as they came up in turn, and the camp rose like magic.

CHAPTER XVIII.

THE INDIAN HUNT.

The camp was full of the newly-cut lodge-poles: some, already prepared, were stacked together, white and glistening, to dry and harden in the sun; others were lying on the ground, and the squaws, the boys, and even some of the warriors, were busily at work peeling off the bark and paring them with their knives to the proper dimensions. Most of the hides obtained at the last camp were dressed and scraped thin enough for use, and many of the squaws were engaged in fitting them together and sewing them with sinews, to form the coverings for the lodges. Men were wandering among the bushes that lined the brook along the margin of the camp, cutting sticks of red willow, or *shongsasha*, the bark of which, mixed with tobacco, they use for smoking. Reynal's squaw was hard at work with her awl and buffalo sinews upon her lodge, while her proprietor, having just finished an enormous breakfast of meat, was smoking a social pipe with Raymond and myself. He proposed at length that we should go out on a hunt. "Go to the Big Crow's lodge," said he, "and get your rifle. I'll bet the gray Wyandot pony

At the Top of the Mountain
Signed lower left, CMR (skull)
3½ x 4½ inches

During a mountain hunt, Parkman climbed to the summit and seated himself on the highest precipice. He said, "Looking between the mountain peaks to the westward, the pale blue prairie was stretching to the farthest horizon like a serene and tranquil ocean." Russell, having done the same many times, knew how to create a scene in which one can look out forever over the land.

Approaching Fort Laramie
Signed lower left, CMR (skull)
2¼ x 4¼ inches

The Indians, having completed their hunt for food, lodge skins, and poles, were ready to turn back toward Fort Laramie. Parkman, who left his cousin and other members of his group at the fort three weeks previous, was also eager to return to the "civilization of the frontier."

Crossing Laramie Creek
Signed lower left, CMR (skull)
5 x 4½ inches

Eager to rejoin his friends, Parkman plunged into the river. Later he wrote, ". . . we raised our feet to the saddle behind us and thus kneeling, as it were, on horseback, passed dry-shod through the swift current." He was met by an enthusiastic welcome which, with all his Bostonian restraint, he could not fail to mention.

Group of Pronghorns
Signed lower left, CMR (skull)
2¼ x 4 inches

48

On the fourth of August, Parkman and his companions headed south along the eastern foothills of the Rockies, toward Bent's Fort. While at times they hunted buffalo for provisions, the antelope, an animal noted both for its flightiness and its curiosity, provided the main staple for the group.

on its extreme point. Looking between the mountain-peaks to the westward, the pale blue prairie was stretching to the farthest horizon, like a serene and tranquil ocean. The surrounding mountains were in themselves sufficiently striking and impressive, but this contrast gave redoubled effect to their stern features.

revelling in the creations of that resplendent genius which has achieved no more signal triumph than that of half beguiling us to forget the unmanly character of its possessor.

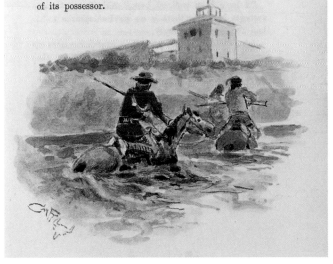

CHAPTER XIX.

PASSAGE OF THE MOUNTAINS.

WHEN I took leave of Shaw at La Bonté's camp, I promised to meet him at Fort Laramie on the first of August. The Indians, too, intended to pass the mountains and move towards the fort. To do so at this point was impossible, because there was no passage; and in order to find one, we were obliged to go twelve or fourteen miles southward. Late in the afternoon the camp got in motion. I rode in company with three or four young Indians at the rear, and the moving swarm stretched before me, in the ruddy light of sunset, or the deep shadow of the mountains, far beyond my sight. It was an ill-omened spot they chose to encamp upon. When they were there just a year before, a war-party of ten men, led by The Whirlwind's son, had gone out against the enemy, and not one had ever returned. This was the immediate cause of this season's warlike preparations. I was not a little astonished, when I came to the camp, at the confusion of horrible sounds with which it was filled: howls, shrieks, and wailings rose from all the women present, many of whom, not content with this exhibition of grief

CHAPTER XX.

THE LONELY JOURNEY.

ON the day of my arrival at Fort Laramie, Shaw and I were lounging on two buffalo-robes in the large apartment hospitably assigned to us; Henry Chatillon also was present, busy about the harness and weapons, which had been brought into the room, and two or three Indians were crouching on the floor, eying us with their fixed, unwavering gaze.

"I have been well off here," said Shaw, "in all respects but one; there is no good *shongsasha* to be had for love or money."

I gave him a small leather bag containing some of excellent quality, which I had brought from the Black Hills. "Now, Henry," said he, "hand me Papin's chopping-board, or give it to that Indian, and let him cut the mixture; they understand it better than any white man."

The Indian, without saying a word, mixed the bark and the tobacco in due proportions, filled the

CHAPTER XXI.

THE PUEBLO AND BENT'S FORT.

WE approached the gate of the Pueblo. It was a wretched species of fort, of most primitive construction, being nothing more than a large square enclosure, surrounded by a wall of mud, miserably cracked and dilapidated. The slender pickets that surmounted it were half broken down, and the gate dangled on its wooden hinges so loosely that to open or shut it seemed likely to fling it down altogether. Two or three squalid Mexicans, with their broad hats, and their vile faces overgrown with hair, were lounging about the bank of the river in front of it. They disappeared as they saw us approach; and as we rode up to the gate, a light active little figure came out to meet us. It was our old friend Richard. He had come from Fort Laramie on a trading expedition to Taos; but finding when he reached the Pueblo that the war would prevent his going farther, he was quietly waiting till the conquest of the country should allow him to proceed. He seemed to feel bound to do the honors of the place. Shaking us warmly by the hand, he led the way into the area.

Here we saw his large Santa Fé wagons standing together. A few squaws and Spanish women, and a

CHAPTER XXII.

TÊTE ROUGE, THE VOLUNTEER.

THE next morning, having directed Deslauriers to repair with his cart to the place of meeting, we came again to the fort to make some arrangements for the journey. After completing these we sat down under a sort of porch, to smoke with some Shienne Indians whom we found there. In a few minutes we saw an extraordinary little figure approach us in a military dress. He had a small, round countenance, garnished about the eyes with the kind of wrinkles commonly known as crow's feet, and surmounted by an

in company with us. We readily assented, for we liked the appearance of the first two men, and were very glad to gain so efficient a reinforcement. We told them to meet us on the next evening at a spot on the river-side, about six miles below the fort. Having smoked a pipe together, our new allies left us, and we lay down to sleep.

that new man of yours, won't count for anything. We'll get through well enough, never fear for that, unless the Comanches happen to get foul of us."

A Mexican at Pueblo
Signed lower right, CMR (skull)
2 x 2 inches

Parkman's group arrived at Pueblo just three weeks after General Kearney's army left Bent's Fort (approximately forty-five miles to the east) to march against Santa Fe and on to California. This was Parkman's first encounter with Mexicans on their own territory, and he had some difficulty accepting their lifestyle, much different from that of the Indians he had just come to know.

Pipe and Tobacco Bag
Not signed
2¾ x 3½ inches

Throughout his journey, Parkman observed the social ceremony of "smoking the pipe" with Indians, traders, trappers, and emigrants. The pipe played a large role in the diplomatic negotiations of all the actors on the western scene.

A Cheyenne Indian
Not signed
2 x 1½ inches

Before leaving Bent's Fort and heading east toward the "settlements," Parkman and Shaw sat down to smoke with some Cheyenne Indians. It was the last time they were to share a pipe with a group of Plains Indians.

Catching Tete-Rouge's Mule
Signed lower right, CMR (skull)
3½ x 3¾ inches

Parkman's expedition picked up more than supplies at Bent's Fort. They were joined by a young man who had arrived at the fort with a company of volunteers from St. Louis. Seriously ill, he had been left when the company moved on to Santa Fe. According to Parkman, he was nicknamed Tete-Rouge (Red Head) by Henry Chatillon. He became the group's court jester on their month-long trip back to civilization.

CHAPTER XXIII.

INDIAN ALARMS.

WE began our journey for the settlements on the twenty-seventh of August, and certainly a more raga-muffin cavalcade never was seen on the banks of the Upper Arkansas. Of the large and fine horses with which we had left the frontier in the spring, not one remained: we had supplied their place with the rough breed of the prairie, as hardy as mules and almost as ugly; we had also with us a number of the latter detestable animals. In spite of their strength and hardihood, several of the band were already worn down by hard service and hard fare, and as

declined to give our judgment on so delicate a matter, the dispute grew hot between Tête Rouge and his accuser, until he was directed to go to bed and not alarm the camp again if he saw the whole Arapahoe village coming.

CHAPTER XXIV.

THE CHASE.

The country before us was now thronged with buffalo, and a sketch of the manner of hunting them will not be out of place. There are two methods commonly practised, "running" and "approaching." The chase on horseback, which goes by the name of "running," is the more violent and dashing mode of the two, that is to say, when the buffalo are in one of their wild moods; for otherwise it is tame enough. A practised and skilful hunter, well mounted, will sometimes kill five or six cows in a single chase, loading his gun again and again as his horse rushes through the tumult. In attacking a small band of buffalo, or in separating a single animal from the herd and assailing it apart from the rest, there is less excitement and less danger. In fact, the animals are at times so stupid and lethargic that there is little sport in killing them. With a bold and well-trained horse the hunter may ride so close to the buffalo that as they gallop side by side he may touch him with his hand; nor is there much danger in this as long as the buffalo's strength and breath continue unabated; but when he becomes tired and can no longer run

CHAPTER XXV.

THE BUFFALO CAMP.

No one in the camp was more active than Jim Gurney, and no one half so lazy as Ellis. Between these two there was a great antipathy. Ellis never stirred in the morning until he was compelled, but Jim was always on his feet before daybreak; and this morning as usual the sound of his voice awakened the party.

"Get up, you booby! up with you now, you're fit for nothing but eating and sleeping. Stop your grumbling and come out of that buffalo-robe, or I'll pull it off for you."

Jim's words were interspersed with numerous expletives, which gave them great additional effect. Ellis drawled out something in a nasal tone from among the folds of his buffalo-robe; then slowly dis-engaged himself, rose into a sitting posture, stretched his long arms, yawned hideously, and, finally raising his tall person erect, stood staring about him to all the four quarters of the horizon. Deslauriers's fire was soon blazing, and the horses and mules, loosened from their pickets, were feeding on the neighboring meadow. When we sat down to breakfast the prairie

An Indian of the Plains
Not signed
1¾ x 2 inches

Parkman's party faced the trip home with genuine concern, since their group was small and they would be traversing land occupied by Pawnees and Arapahoes. Both of these tribes had, in the recent past, displayed hostile attitudes toward white men crossing their territory.

Arapahoe Warrior
Not signed
2¾ x 2¼ inches

Whether the Arapahoes were subdued by General Kearney's admonitions against attacking whites or whether they were simply more interested in the buffalo hunt they were engaged in is uncertain. Whatever the case, when Parkman's party came to an Arapahoe village camped along the Arkansas, they were accepted into the Indians' lodges and were given a bowl of boiled meat, although Parkman noted no pipe was offered them. He was aware the Arapahoes set great store in their war shields, and he wished to trade for one. Russell paints the Arapahoe warrior with his shield prominently displayed upon his arm.

Shaw into the Hunt
Signed lower left, CMR (skull)
3¾ x 4¼ inches

The party was crossing prime buffalo country. For several days, hunting the shaggy beasts was their main occupation. Parkman and his cousin Shaw, despite their Boston background and lack of frontier experience, proved themselves capable in the hunt.

The Buffalo Bulls
Signed lower right, CMR (skull)
2¾ x 4¼ inches

The buffalo was a mighty symbol to Charles Russell throughout his artistic career. He once lamented that the animal had not been given the recognition it deserved. In a Thanksgiving letter to Ralph Budd, President of the Great Northern Railroad, Russell said, ". . . the turkey is the emblem of the day—and it should be in the East—the West owes nothing to that bird but it owes much to the humped-back beef—he fed the explorer—the great fur trade wagons felt safe when they reached his range—there is no day set aside where he is an emblem—the nickel wears his picture—dam small money for so much meat."

we had advanced about a mile, Shaw missed a valuable hunting-knife, and turned back in search of it, thinking that he had left it at the camp. The day was dark and gloomy. The ashes of the fires were still smoking by the river-side; the grass around them was trampled down by men and horses, and strewn with all the litter of a camp. Our departure had been a gathering signal to the birds and beasts of prey. Scores of wolves were prowling about the smouldering fires, while multitudes were roaming over the neighboring prairie; they all fled as Shaw approached, some running over the sand-beds and some over the grassy plains. The vultures in great clouds were soaring overhead, and the dead bull near the camp was completely blackened by the flock that had alighted upon it; they flapped their broad wings, and stretched upwards their crested heads and long skinny necks, fearing to remain, yet reluctant to leave their disgusting feast. As he searched about the fires he saw the wolves seated on the hills waiting for his departure. Having looked in vain for his knife, he mounted again, and left the wolves and the vultures to banquet undisturbed.

CHAPTER XXVII.

THE SETTLEMENTS.

THE next day was extremely hot, and we rode from morning till night without seeing a tree, a bush, or a drop of water. Our horses and mules suffered much more than we, but as sunset approached, they pricked up their ears and mended their pace. Water was not far off. When we came to the descent of the broad shallow valley where it lay, an unlooked-for sight awaited us. The stream glistened at the bottom, and along its banks were pitched a multitude of tents, while hundreds of cattle were feeding over

CHAPTER XXVI.

DOWN THE ARKANSAS.

IN the summer of 1846, the wild and lonely banks of the Upper Arkansas beheld for the first time the passage of an army. General Kearney, on his march to Santa Fé, adopted this route in preference to the old trail of the Cimarron. When we were on the Arkansas, the main body of the troops had already passed on; Price's Missouri regiment, however, was still on its way, having left the frontier much later than the rest; and about this time we began to meet one or two companies at a time moving along the

streets of St. Louis would have taken him for a hunter fresh from the Rocky Mountains. He was very neatly and simply dressed in a suit of dark cloth; for although since his sixteenth year he had scarcely been for a month together among the abodes of men, he had a native good taste which always led him to pay great attention to his personal appearance. His tall athletic figure with its easy flexible motions appeared to advantage in his present dress; and his fine face, though roughened by a thousand storms, was not at all out of keeping with it. He had served us with a fidelity and zeal beyond all praise. We took leave of him with regret; and unless his changing features, as he shook us by the hand, belied him, the feeling on his part was no less than on ours. Shaw had given him a horse at Westport. My rifle, an excellent piece, which he had always been fond of using, is now in his hands, and perhaps at this moment its sharp voice is startling the echoes of the Rocky Mountains. On the next morning we left town, and after a fortnight of railroads, coaches, and steamboats, saw once more the familiar features of home.

Around the Ashes of the Fire
Signed lower left, CMR (skull)
2¼ x 4¼ inches

Russell had used the grey wolf as a symbol of the untamed western lands in his introductory illustration where emigrants are making their first tracks into unknown territory. As Parkman's group leaves the frontier and heads toward civilization, the artist creates a scene in which the land, once again, is left to the grey wolf and the vulture.

Buffalo Bull
Not signed
1¾ x 1½ inches

As it fed, housed, and provided a moving spirit for the Indian, so the buffalo provided food aplenty for the Parkman party's homeward-bound journey. In two days' hunt, the extraordinary skill of Henry Chatillon provided sufficient meat from fat cows to supply the group on its month-long trek toward St. Louis.

White Man's Dwelling
Not signed
2½ x 4 inches

Autumn was tingeing the stands of oak, maple, and hickory when Parkman's group rode back into the fertile country surrounding Westport. Around them, civilization burst forth with an abundant harvest. Yet, as the young easterner stated, "We saw the roof of a white man's dwelling between the opening trees . . . [at the same time] . . . we looked back regretfully to the wilderness behind us."

Last Vestige of the Frontier
Not signed
2¼ x 2 inches

At age fourteen, two years before traveling to Montana territory, Russell used a buffalo skull in a small watercolor he painted, used it as a coda to the song he would henceforth sing of the Old West. Few paintings he created after that lacked the motif. By 1889, he had incorporated the outline of the skull into his signature. By 1921, when he lovingly painted these fifty watercolor sketches into Armstrong's books, Russell thought of himself as a "last vestige of the old days." He longed for the time when the land was unbroken by fences, a time before the grass was plowed under and the humpbacked buffalo and his cousin, the longhorned steer, had passed into history. It was entirely appropriate that the artist would have "signed" the final page of the books with a sun-bleached buffalo skull.

THE ART

The Forked Trail
Oil on canvas, 6¹⁵⁄₁₆ x 10⅞ inches
Signed lower left, CM Russell (skull) 1903
Ex-collections: Kennedy Galleries, New York, New York
 Clara Peck, New York, New York

A small party of Piegans rides out of the broad valley of the Sun River. In all likelihood, they are scouting for buffalo—the group is too small for a war party. Their shields and lances are more ceremonial than necessary accoutrements. The warriors and hunters of the Blackfoot Confederacy put great store in arming themselves properly for any activity.

One trail may have led to the buffalo grounds, another might have led to dangerous attacks on or by their enemies. Russell, the great storyteller, never tells us the entire plot. He leaves the viewer to create the outcome of the actions in his art work.

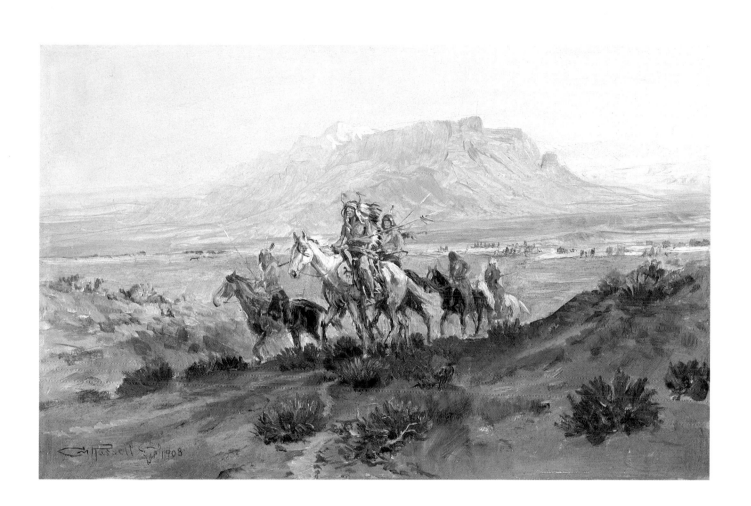

The West
Oil on canvas, 11½ x 14½ inches
Signed lower right, CM Russell (skull) 1913
Ex-collections: Willets H. Sawyer, Columbus, Ohio
 Clara Peck, New York, New York

With the exception of the horse, no other animal was painted, drawn, or sculpted more frequently by Charles Russell than the buffalo. He paid tribute, time and again, to its might and power and its supreme position in the ecology of the West. The buffalo provided food, lodging, clothes, tools, household equipment, sport, and spiritual inspiration for the Indians of the plains. Charlie said of them: "If it had not been for this animal the West would have been the land of starvation—for over a hundred years he fed and made beds for our frontier and it sure looks like we could feed and protect a few hundred of them."

In *The West,* the ruler of the plains, the buffalo, and the scavenger of the prairies, the grey wolf, are squared off against each other. Actually, the wolf was usually only a minor irritant to the great, shaggy beasts, as old and crippled bulls or newborn calves provided the main food source for the wolf pack. But they managed to occupy the same territory without great damage to each other, a characteristic greatly admired by Russell.

Bear at Lake
Oil on canvas, 10½ x 14 inches
Unsigned. ca. 1888
Ex-collections: Phil Weinhard, High River, Alberta
 H. E. Britzman, Pasadena, California
 Hammer Galleries, New York, New York
 Clara Peck, New York, New York

In the summer of 1888, Charlie Russell, with friends Phil Weinhard and Long Green Stillwell, traveled to the small town of High River in Alberta, Canada. Weinhard had a job offer at a ranch several miles out of town. Russell and Stillwell camped for the summer in a cabin owned by an Englishman, Charles Blunt, an amateur painter. Russell appropriated some art supplies left in the cabin and painted several oils and watercolors, *Bear at Lake* being one of them. When the snows came, the two cowboys started south toward Montana. Weinhard, coming into town for supplies, found the boys gone but the paintings still in the cabin, possibly left as "rent" for Blunt's cabin. Nevertheless, Weinhard took possession of them, and in 1939 sold the pieces to Homer Britzman of Southern California.

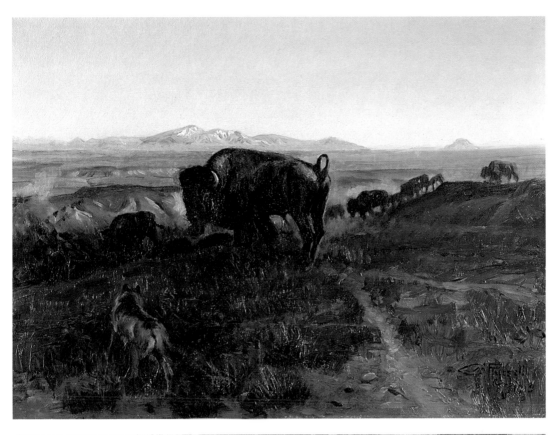

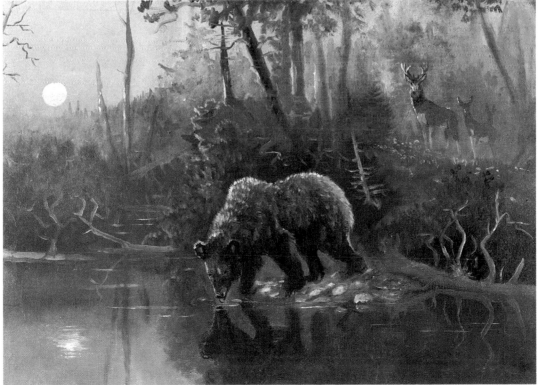

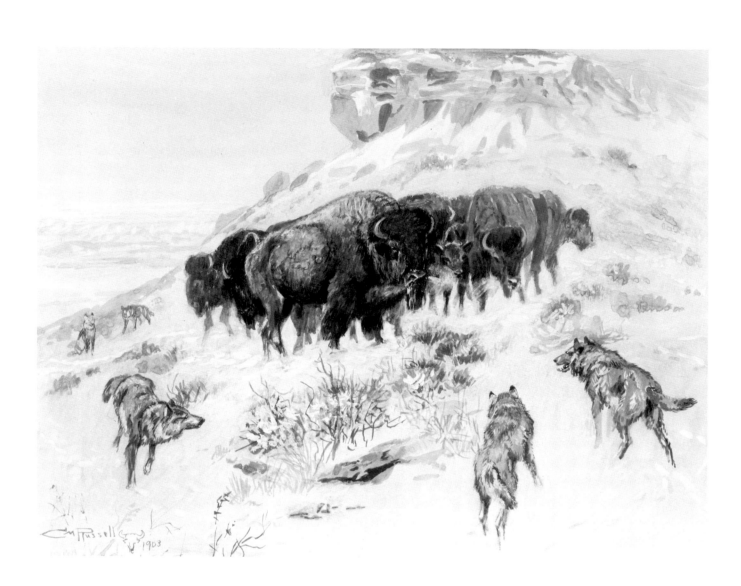

Buffalo and Wolves
Watercolor on paper, 9½ x 13 inches
Signed lower left, CM Russell (skull) 1903
Ex-collection: M. Knoedler Gallery, New York, New York

It might appear the wolves offer a serious challenge to the small group of buffalo huddled together under the protection of the rocky escarpment. They are cunning, quick of movement, and tenacious. But that judgment ignores the advantage held by the lead bull of the herd. Eyeing his circling adversaries, his tail curled high, he watches for any advance. Powerful heels, sharp horns, and a massive head that can toss a sixty-pound wolf down the slope are sufficient weapons. The adults encircle the young calf, protecting it with their huge bodies, their eyes alert for any movement.

The Train Robbery
Pen and ink on paper, 11 x 9⅜ inches
Signed lower left, CMR (skull) 1907
Ex-collection: Nick Wolochuck, Santa Fe, New Mexico

The unusual brand on the near horse in the sketch was obviously a favorite of the artist, as it appears in a number of other drawings, watercolors, and oils, including *The Trail Boss, Bronc to Breakfast, A Loose Cinch and a Tight Latigo,* as well as on his first bronze, *Smoking Up.*

 The Train Robbery was one of the thirty-two illustrations Russell did for *The Lure of Dim Trails,* by B. M. Bower, published in 1907. In composition and theme, the piece is a forerunner for one of Russell's most important watercolors, *Innocent Allies,* painted six years later in 1913.

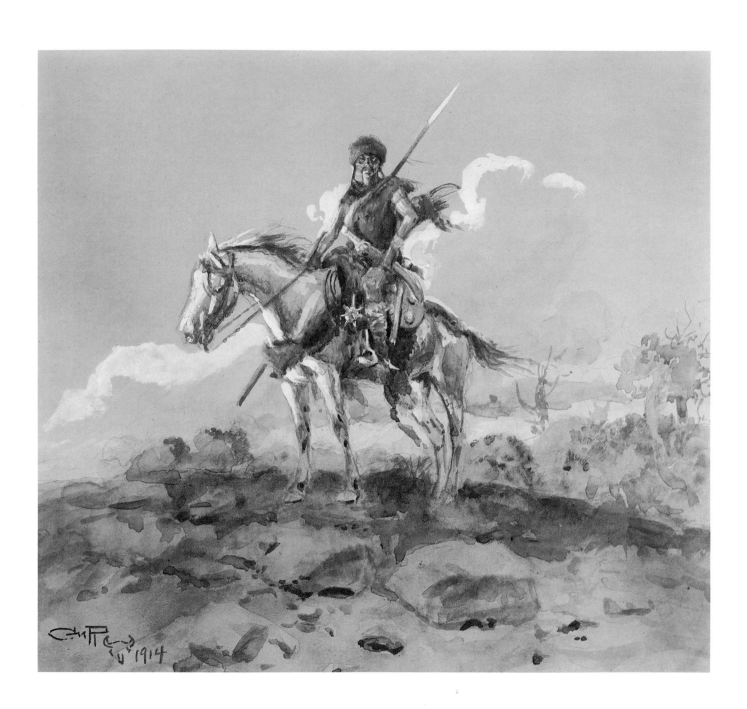

Manchurian Warrior
Watercolor on paper, 10¼ x 11⅜ inches
Signed lower left, CMR (skull) 1914
Ex-collection: Harold McCracken, Cody, Wyoming

Charlie's nephew, Austin Russell, had romantic yearnings toward the Mid and Far East. Austin notes that Charlie painted a full-sized watercolor for him of Attila the Hun as well as one of Parthian Gotarzes, who, in 91–87 B.C., was a king in the area now known as Iran.

It is likely that Russell's *Manchurian Warrior* was a similar creation, an exercise for the artist who was continually intrigued by all things distant, strange, colorful, and exotic.

Steve Marshland Was Hanged by Vigilantes
Pen and ink on paper, 9 x 11 inches
Signed lower left, CM Russell (skull) 1918
Ex-collections: Nancy C. Russell estate, Pasadena, California
 C. R. Smith, New York, New York
 H. E. Britzman, Pasadena, California
 Hammer Galleries, New York, New York
 Buckholz Galleries, Bradford, Pennsylvania

Steve Marshland, reputed to be a college graduate, was a member of Henry Plummer's notorious gang of outlaws and road agents. Early in December 1863, Plummer got word of a wagon train leaving Bannock, Montana, with seventy-five thousand dollars in gold, and he ordered Dutch John Wagner and Steve Marshland to intercept the train and collect the booty. Coming on the wagon train unexpectedly, the two unmasked outlaws were recognized. The packers opened fire, and both outlaws were wounded but got away. A patrol of vigilantes traced Marshland to Clarke's ranch near Big Hole on January 15, 1864, where he was found in bed with both feet frozen. Protesting his innocence at first, he confessed to the attempted robbery only after an examination revealed the damning bullet hole in his chest. He was promptly judged guilty, hanged, and buried.

Cowboy on a Bucking Horse
Pen and ink on paper, 9⅛ x 11 inches
Signed lower left, CMR (skull) ca. 1907

B. M. Bower, the pen name for Montanan Bertha Muzzy Bower, wrote several fairly successful romantic western novels, four of which Russell illustrated. *Cowboy on a Bucking Horse* is one of twenty-nine pen and ink sketches, plus three full-color illustrations, that the cowboy artist did for Bower's third book, *The Lure of Dim Trails.* Although it contains the standard violence and action of typical western stories, i.e., a train robbery and an aborted hanging by a vigilante group, the book is principally a love story between a ranch girl and an eastern author who comes to Montana seeking local color for his writings. Obviously, the author gave Russell a free hand in his illustrations, for several of the line drawings, including this one, have little relationship to the text.

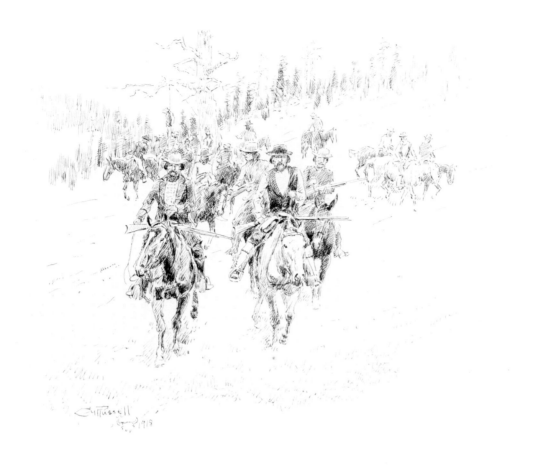

Piegan Chief
Watercolor on paper, 14 x 12 inches
Signed lower left, CM Russell (skull) 1912
Ex-collections: Alice Calvert, Great Falls, Montana
 F. G. Renner, Washington, D.C.
 Gordon Renner, Torrance, California

When Russell first came to Montana, intertribal warfare had been quelled by the U.S. government and by the various tribes' submission to its political power. However, raids on horses and cattle occurred sporadically. It was a last feint by men who for centuries had roamed freely over hundreds of miles, making their own laws, living by their own concepts. Russell was never inspired to paint the Indian in his last hurrah. He imagined the Indian in the glory of his days before the white man, before guns—when lances and bows and arrows were his effective weapons and he decorated his favorite horse with eagle feathers, riding into battle with great honor.

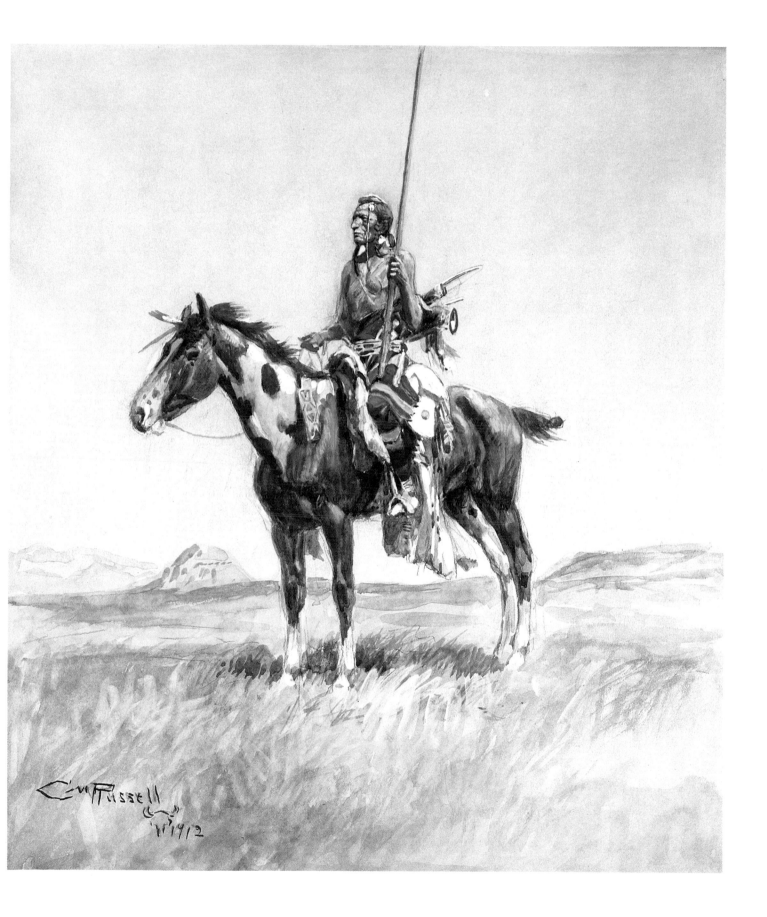

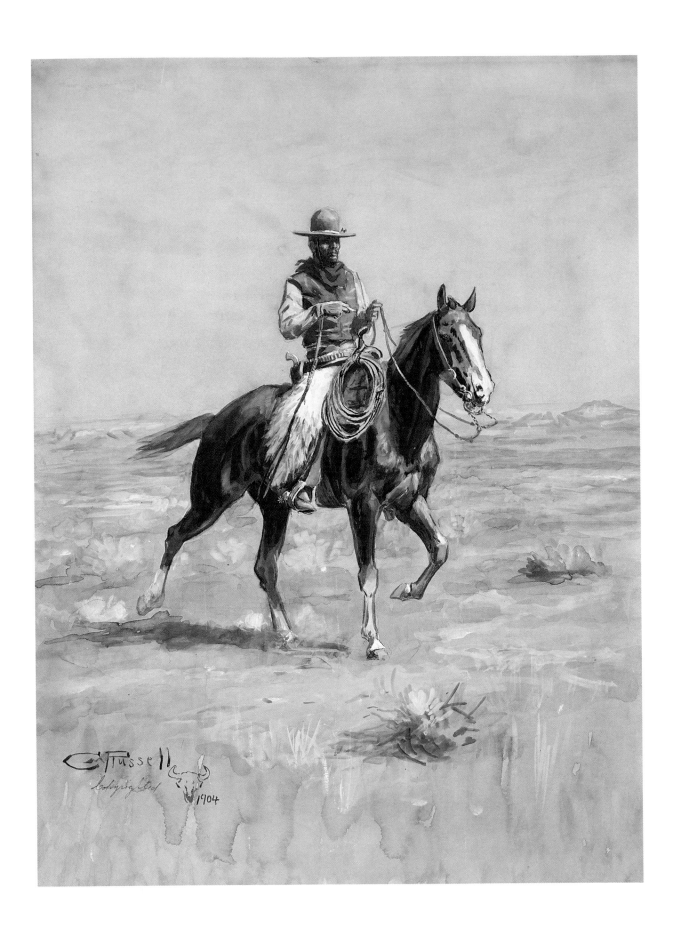

Cowboy
Watercolor on paper, 15½ x 11½ inches
Signed lower left, CM Russell. Copyright (skull) 1904
Ex-collections: F. G. Renner, Washington, D.C.
 Gordon Renner, Torrance, California

In Charlie Russell's eyes, a "top hand on a top horse" had as his predecessor a "knight in shining armor." A man on horseback has been a mighty symbol for thousands of years. To Charlie, they were "regular men"—the highest compliment he could pay to his fellow man. He knew the pride they felt, those regular men, in a good outfit, in "horse jewelry" that caught the sun's rays and flashed across the prairie, in an alert horse whose ears were up, and in a man who knew full well his own worth.

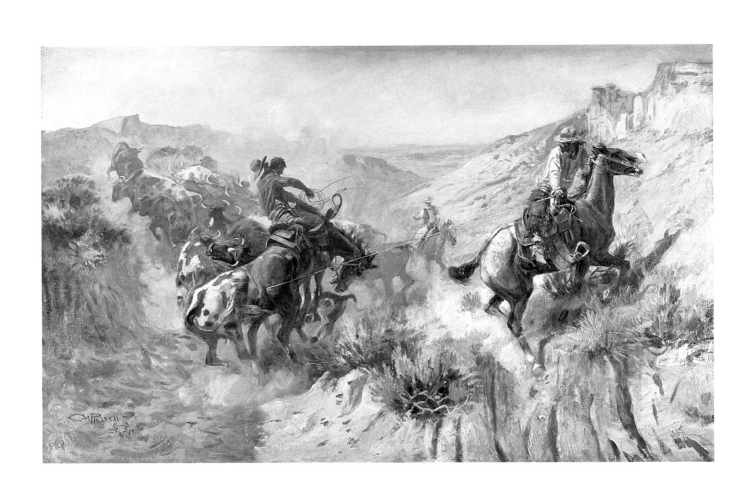

A Mix Up
Oil on canvas, 30 x 48 inches
Signed lower left, CM Russell (skull) 1910
Ex-collections: Sir Henry Pellat, Toronto, Canada
 Amon Carter Museum, Fort Worth, Texas
 F. G. Renner, Washington, D.C.

Without question, *A Mix Up* is the grandest jewel in the crown of Russell art in the Rockwell collection. It is Charlie at his best. No other western artist has ever been able to dream up more exciting, tension-packed action pictures—usually small moments of every-day occurrences—and turn them into immortal dramas.

The top hand on the roan, the rep for the R. W. Clifford outfit out of Ubet, is in trouble. An inexperienced hand has gotten himself in the wrong place at the wrong time. Of such minor incidents are great dramas made—at least by Russell.

The magnificent oil was listed in the leaflet of the special exhibition of C. M. Russell's work at the Calgary Stampede in 1912, erroneously titled *Heads or Tails*. It was purchased at that first international exhibition by Sir Henry Pellat, commander of the "Queen's Own Rifles," who at the same time purchased *In Without Knocking*—an opportunity that makes present-day Russell collectors envious.

Idaho Ox Teams Were Bringing in Some 6,000,000 Pounds of Freight Annually
Pen and ink on paper, 13 x 17 inches
Signed lower left, CMR (skull) ca. 1910
Ex-collections: Nancy C. Russell estate, Pasadena, California
 C. R. Smith, New York, New York
 F. G. Renner, Washington, D.C.
 Walter Latendorf, New York, New York

Nineteen ten marked the peak of Charles M. Russell's career as an illustrator, with monumental commissions for forty-three illustrations in Owen Wister's special limited edition of *The Virginian* and for eighty-five illustrations for Carrie Adell Strahorn's *Fifteen Thousand Miles by Stage,* both published the following year.

Beginning in 1877 at Omaha, Mrs. Strahorn's travels took her through nine of the western states as well as British Columbia and Hawaii. Her six hundred seventy-three-page account of the fascinating incidents and characters she encountered inspired some of Russell's finest watercolors and pen drawings, this piece among them.

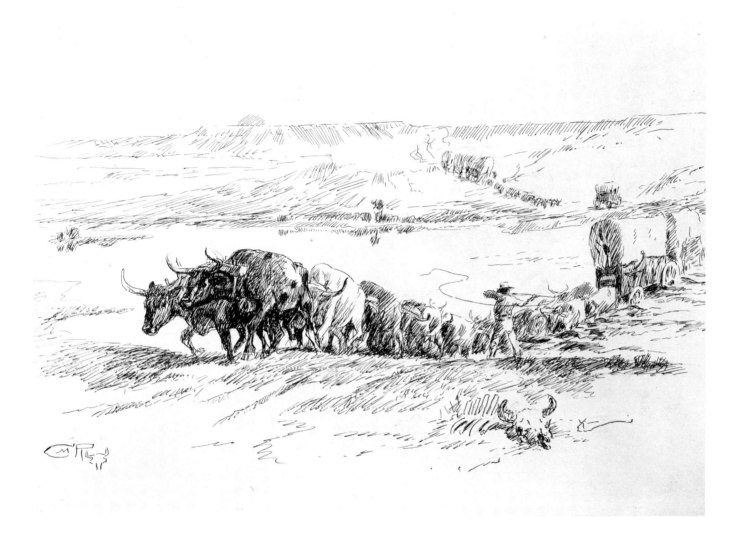

The Robe Trader
Pen and ink on paper, 12 x 9 inches
Unsigned, ca. 1898
Ex-collections: Nancy C. Russell estate, Pasadena, California
 C. R. Smith, New York, New York
 F. G. Renner, Washington, D.C.

Russell sometimes found it helpful to make preliminary drawings of some of the central figures that were to appear in a finished work, particularly if the subject was one he hadn't previously attempted. This is obviously a preliminary sketch for two of the figures for his fine watercolor, *Joe Kipp's Trading Post,* Russell's only depiction of the interior of an Indian trading post. Most such preparatory sketches were discarded or lost, but the artist's wife, Nancy, thought this one important enough to save.

Indian Head
Pen and ink on paper, 9 x 6½ inches
Signed lower left, CM Russell (skull) ca. 1890
Ex-collection: James Graham & Sons, New York, New York

In his formative years, Russell experimented in many ways. His first commission, according to his young love, Laura Edgar, was a poster with a center scene of a stagecoach, surrounded by sketches of different aspects of range life, or of equipment or gear needed by the cowman of the 1880s. Only a few montages were created before Russell abandoned the idea. This pen drawing is one of the very few of this type to survive.

Here, a formal portrait of an Indian warrior is surrounded by vignettes of an Indian camp scene on the upper right and a burial scaffold at the upper left. The latter is embellished with drawings of the Indian's prized possessions: his tomahawk, war club, quiver, and pipe.

This drawing was probably a gift to a friend, who took it to the LeMunajun Studio in Great Falls and had it photographed.

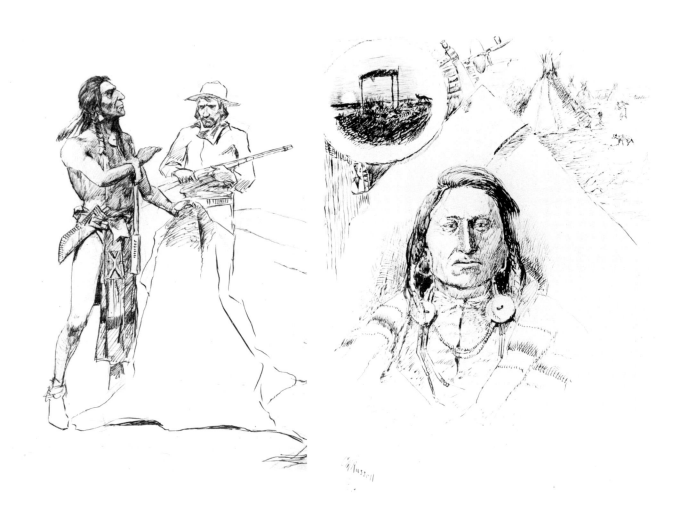

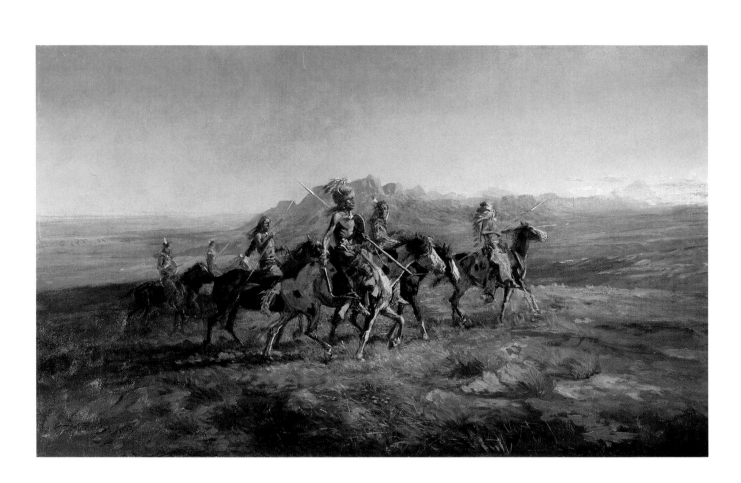

Sun River War Party
Oil on canvas, 18 x 30 inches
Signed lower left, CM Russell (skull) 1903

Heading west up the hills that border the Sun River, a small party of Piegans ride in comfortable triumph. Their foray was, by their satisfied appearance, a successful one. Three Suns, a noted Pikuni chief and warrior (Pikuni is the tribal name for Piegans), spoke of the wintering places of his people along the Sun River: "[It] afforded good shelter and wood for our lodges; and buffalo, elk, deer, antelope and beavers were very plentiful."

Today, along the winding breaks of the river, one can still see the rock tipi circles marking the winter home of these nomadic tribes.

A Party of Sitting Bull's Braves Get on Our Trail
Watercolor on paper, 16 x 11½ inches
Signed lower left, CM Russell (skull) ca. 1922
Ex-collection: M. Knoedler Gallery, New York, New York

In the fall of 1881, the *Chicago Times,* alarmed at increasing rumors of Indian hostilities in Montana, sent veteran reporter Charles S. Diehl to investigate the situation. Finding all quiet at Wolf Point, Diehl decided to pay a visit to Sitting Bull himself, then camped with his followers at the mouth of the Milk River, some thirty-five miles distant. Warned that Sitting Bull was vindictive, treacherous, and that a white man took great chances with his life by going near his camp, Diehl set out with a guide and Allison, a Sioux interpreter.

As he was to tell the story later, "The second day, when within a couple of miles from Sitting Bull's camp, we met a party of his braves who stopped us and acted in a very ugly manner. They told us to go on toward the camp but a half dozen of them surrounded Allison and started beating him with their quirts. As we approached the lodges they stopped, as it is contrary to Indian ideas to abuse anyone inside the camp."

Russell's illustration of this incident, along with a complete story of Diehl's visit with Sitting Bull, was later published in the Montana *Bynum Herald* on February 13, 1922.

Three Indian Warriors
Watercolor on paper, 11½ x 16 inches
Unsigned, ca. 1922

(painted on reverse of *A Party of Sitting Bull's Braves Get on Our Trail*)

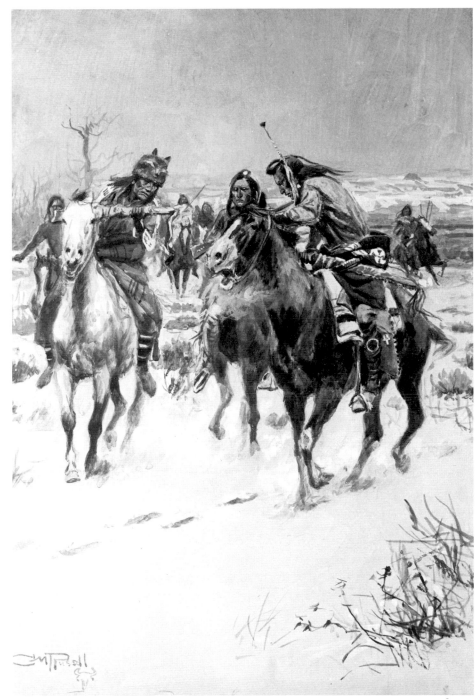

One Down, Two to Go
Watercolor on paper, 19⅝ x 29½ inches
Signed lower left, CM Russell (skull) 1902
Ex-collection: Buckholz Galleries, Bradford, Pennsylvania

The incident depicted in *One Down, Two to Go* was one Charlie Russell had personally experienced. Austin Russell, in the splendid biography of his uncle, writes: "In every beef herd there are always a few solitary, hermit-minded steers, blighted beings who wander off by themselves, like rogue elephants in Ceylon; these are always the most ugly and dangerous. And a steer, with his needle-pointed horns, is better equipped than most neurotics to implement his resentment. [One time] Charlie came suddenly on one of these hermits, a big longhorn in a vicious state of mind. The steer was prepared; Charlie wasn't. Before he could unloop his rope the steer jumped him, got him in the cut, and crowded him right up against the bank."

Such a heart-stopping, blood-racing crisis would leave an indelible mark on the bravest of men. It certainly did on Russell, for he painted not only this scene from his personal experience but two similar ones, *The Mad Cow* and *A Serious Predicament.*

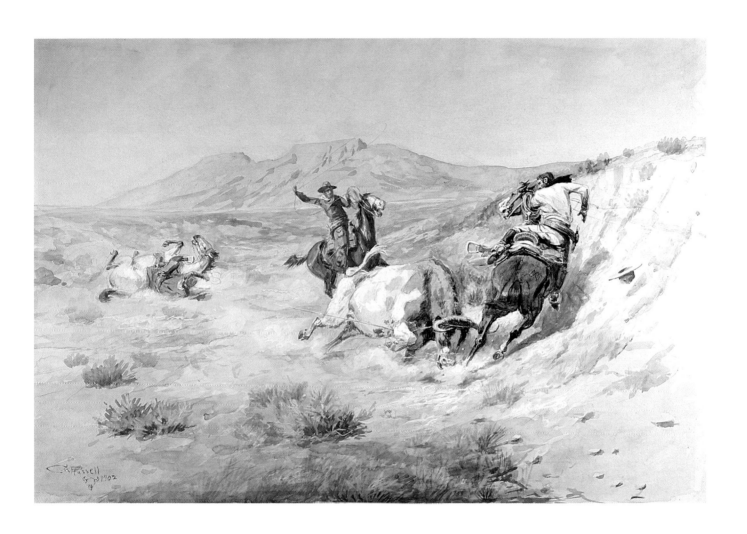

Pinto
Oil on canvas, 14¼ x 11 inches
Signed lower left, CMR ca. 1887
Ex-collections: Robert Thoroughman, Fort Shaw, Montana
 Mrs. Eula Thoroughman, Fort Shaw, Montana
 F. G. Renner, Washington, D.C.

Known for his unusual marking, Pinto was the favorite roping horse of Bob Thoroughman, an early Montana cowboy who became one of the most respected ranchers in the Sun River country. In the summer of 1879, Thoroughman and a cowboy named Morgan were hired to move a large herd of cattle from the Big Hole country to the Sands and Taylor ranch east of Choteau. Waking up one morning, they found that their horse herd, Pinto among them, had been stolen by the Indians. Morgan was sent out in pursuit, and along the way he was joined by several settlers who had also been robbed. The party, about twelve in number, caught up with the horse thieves near White Sulphur Springs, and a pitched battle ensued. During the battle, Pinto recognized the horse Morgan was riding and came trotting over. Morgan, seeing the horse was fresh, switched over to Pinto and rode out the battle on the oddly marked horse. The herd was recovered but only after nine of the ten Indians and one settler had been killed. Pinto gained further fame and immortality, as Thoroughman and his faithful horse are the subject of one of Russell's much-admired action scenes, *Bronc in a Cow Camp*.

86

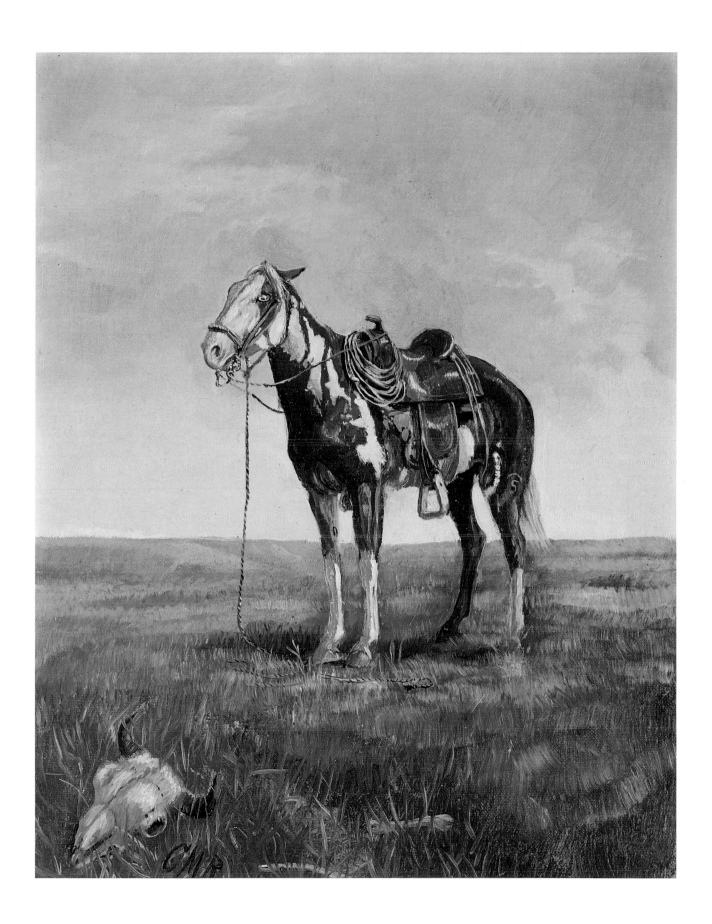

Chief Bear Claw
Watercolor on paper, 12 x 9 inches
Signed lower left, CM Russell (skull) 1900
Ex-collection: F. G. Renner, Washington, D.C.

Charlie Russell began to paint Indian portraits when he was a boy of eleven or twelve, inspired largely by his fertile and highly romantic imagination. But after he came to Montana, these portraits, which he continued to execute the remainder of his life, were of individual Indians, either ones he had personally seen or known or those whose features had been described to him. He seldom, if ever, did a stereotyped portrayal.

Early in his life, he developed a great admiration for Indians and their way of life, and with few exceptions he painted them with dignity and honor. If, as we suspect, Chief Bear Claw was a Blackfoot, he was undoubtedly a man of stature within his tribe. His handsomely decorated buckskin shirt and the bear-claw necklace attest to great courage, for according to John Ewers, authority on the Blackfoot Confederacy, "Adventurous young men hunted the powerful grizzly bear for its claws, which they proudly displayed in the form of necklaces. However, most Blackfoot Indians feared and avoided this dangerous beast. They regarded it as a sacred animal of great supernatural as well as physical power."

Chief Portrait #8
Watercolor on paper, 8 x 6 inches
Signed lower left, CM Russell (skull) 1903
Ex-collection: Hammer Galleries, New York, New York

Fifteen years before Russell painted this portrait of a stalwart, proud, and probably curmudgeonly chief, he had spent several months with a small band of Blood, or Kainah, Indians, the northernmost tribe of the Blackfoot Confederacy. Charlie was still young, still very impressionable. But the impact of his association with this band affected his life thereafter. He painted these people not as they were in 1903, beaten down by repressive laws and treaties the white man had imposed upon them, but as they were when they roamed free over vast territory and were masters of their own fates.

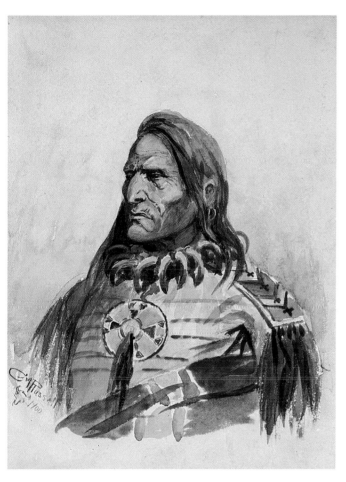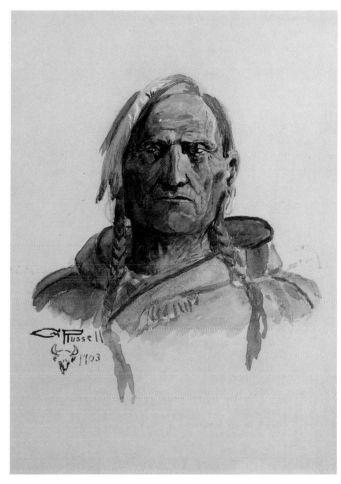

Stolen Horses
Oil on board, 18 x 24 inches
Signed lower left, CM Russell (skull) 1898
Ex-collections: C. J. McNamara, Big Sandy, Montana
 Buckholz Galleries, Bradford, Pennsylvania

In the mid-nineteenth century, the Blackfoot tribes were described as "the most numerous and bloodthirsty nation on the upper Missouri." And according to the noted anthropologist, John Ewers, they were certainly the most aggressive. They raided south into Crow country, crossed the Rockies to attack the Flatheads, Pend d'Oreilles, Kutenais, and Shoshonis, and their mortal enemies were the Assiniboins and the Crees. By far, the general purpose of their raids was not to decimate their enemies, but to aggrandize their own personal stature and wealth by capturing horses, the blue chip stock of the Plains Indian tribes.

The raiding parties, generally small and carefully organized, were led by an experienced warrior and were used as training activities for the teen-aged boys of the tribe. Members of the group resorted to prayerful thought and much reliance on their "medicine" to give them protection during the upcoming raid. Lightly armed and with a minimum of supplies, they went out on foot, often covering three hundred miles in twelve to fourteen days before coming into enemy territory. The safe return back to their lodges, with a band of forty to fifty horses, was an occasion of much rejoicing.

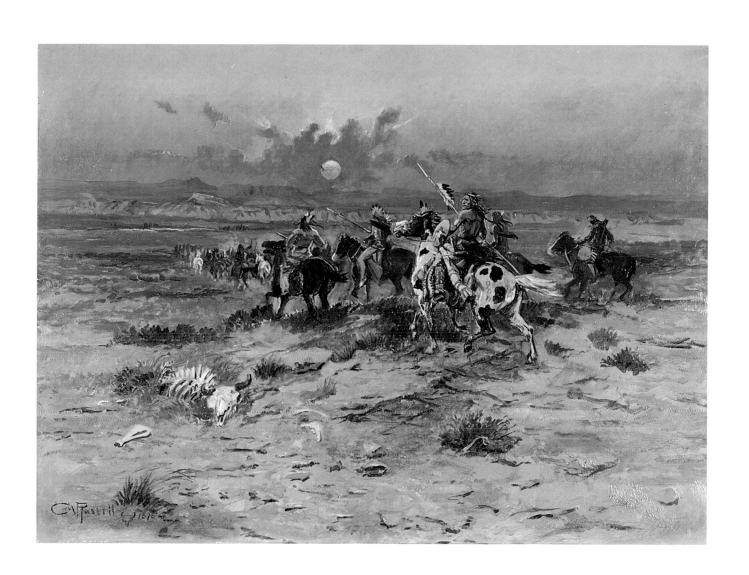

The Initiation of the Tenderfoot
Pen and ink on paper, 14 x 18 inches
Unsigned, ca. 1899
Ex-collection: Hammer Galleries, New York, New York

The two cowboys, bent on mischief, have kindly consented to let the recent arrival from back East take a ride, after assuring him the animal is "plumb gentle." The wicked look in the eyes of the horse suggests he is also in on the conspiracy and will give the tenderfoot the experience of his life. Had the pilgrim been a little more knowledgeable in the ways of the West, the numerous brands on the horse might have suggested there was a good reason he had had so many owners.

Russell usually left the outcome of such confrontations to the imagination of the viewer. In this instance, he provided us with a sequel. In a companion drawing titled *Initiated,* the tenderfoot is in the dust, the horse is taking off for parts unknown, and the two cowboys are laughing uproariously at the success of their prank. The two drawings were published in the artist's second book, *Pen Sketches.*

Curley Reaches the Far West with the Story of the Custer Fight
Pen and ink on paper, 12½ x 20½ inches
Signed lower left, CM Russell (skull) 1922
Ex-collections: Nancy C. Russell estate, Pasadena, California
 C. R. Smith, New York, New York
 F. G. Renner, Washington, D.C.

In 1922, Russell undertook the considerable task of illustrating a series of fifty-two stories titled "Back-Trailing on the Old Frontiers," which were to appear in the Sunday editions of some seventy newspapers from coast to coast. The stories were well-written accounts of important historical events and ranged from Coronado's conquest of the Southwest in 1540, through the periods of the fur trade, Indian battles, and frontier settlement, to the days of the Montana cowboy some three and a half centuries later.

Curley (in some accounts spelled Curly), the seventeen-year-old Crow scout attached to General George Custer's Seventh Cavalry, has been the subject of numerous and contradictory apocryphal tales. It is, however, recorded that on June 27, 1876, two days following the disastrous Battle of the Little Big Horn, he appeared on the river bank where the *Far West,* the supply boat for the Sioux campaign, was tied up at the confluence of the Little and Big Horn rivers. Unable to speak English and without an interpreter, Curley drew a picture of the battlefield layout, and with many gestures, indicated to the crew that the Seventh Cavalry had suffered an overwhelming defeat.

So Me Run Up Behind, Shove de Gun in His Back
Pen and ink on paper, 12½ x 18⅝ inches
Signed lower left, CM Russell (skull) ca. 1899
Ex-collections: Richard Flood, Idaho Falls, Idaho
 Hammer Galleries, New York, New York

When a Nez Perce Indian named Black Cloud captured the wife of an Assiniboin half-breed, the husband was naturally upset. After all, the wife had cost him seventeen ponies and four sacks of tobacco. Years later the two enemies met again, the Nez Perce so engrossed in his pursuit of the buffalo he didn't see the approach of the half-breed until it was too late. Russell's drawing of the encounter was for his friend, Wallace D. Coburn. The story it illustrated was in his *Rhymes from the Round-up Camp.* The first edition of this book is perhaps the scarcest and most sought after of all the books Russell illustrated.

95

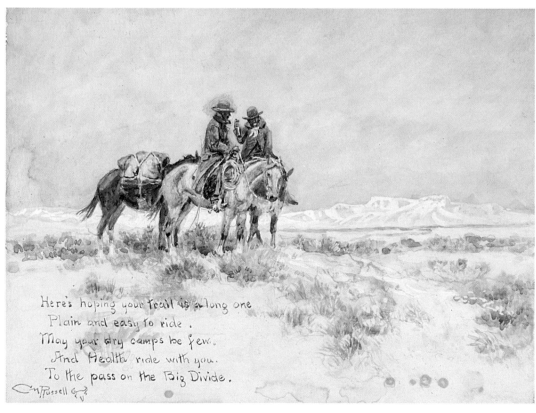

Here's hoping your trail is a long one
 Plain and easy to ride .
May your dry camps be few.
 And Health ride with you.
 To the pass on the Big Divide.

Dudes
Watercolor on paper, 7 x 9 inches
Signed lower right, CM Russell (skull) 1915
Ex-collections: Nancy C. Russell estate, Pasadena, California
 C. R. Smith, New York, New York
 Homer Britzman, Pasadena, California
 Hammer Galleries, New York, New York

By and large, Charlie Russell dealt with dudes in a much gentler manner than he did "punkin rollers" or "nesters." The latter invariably elicited his scorn, and his wit turned caustic when he spoke or wrote of them. Perhaps because Charlie himself joined groups of dudes on several occasions over the years, taking extended pack trips with Howard Eaton to Glacier Park and into Arizona, he could view the dudes in a more amicable light. They were, after all, only a temporary aberration on the western landscape!

 This watercolor, featuring the little creatures Charlie loved so well, was probably intended to be accompanied by a humorous caption. Unfortunately, that small bit of Russell's humor is lost forever.

Here's Hoping Your Trail is a Long One
Watercolor on paper, 8½ x 11 inches
Signed lower left, CM Russell (skull) ca. 1924
Ex-collections: Grand Central Galleries, New York, New York
 J. N. Bartfield Galleries, New York, New York

Charlie Russell threw all his creative forces into embellishing the holiday season with special decorations, gifts for dear friends, and personal, illustrated greetings. By 1924, his Christmas card list for very special friends had outgrown his capacity to make individual watercolor drawings for each recipient. He resorted to painting this small scene, and had it photographed; he then hand-colored fifty or more copies. As usual, he called upon his dear friend and neighbor, Josephine Trigg, to execute the calligraphy for his poem.

97

C. M. RUSSELL
GREAT FALLS, MONTANA

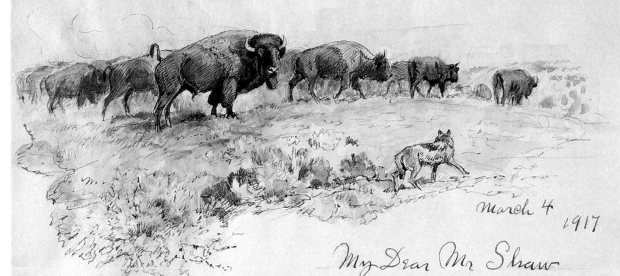

March 4 1917

My Dear Mr Shaw

I did not get your letter till I reached home
but I thank you and Mr Lindsley for the kind
invitation and if that invite holds good I may
visit him som other time maby next year
I would like to have one more look at a game country
before they turn the parke in to a sheep range
and they geysers to a steam laundrey
theirs an aufall wast of hot water in the Yellowstone
park enough to wash in side and out all the reformers
in the state and theirs a fiew of them

thanking you again and if you ever cross
my range the latch strings out

C M Russell

A Game Country
One watercolor illustration, 11 x 8½ inches
Signed CM Russell (letter); illustration not signed; March 1917
Ex-collection: Mrs. Donald Shaw, Paonia, Colorado

The Mr. Shaw to whom this letter was addressed was a general partner in Shaw-Powell Camping Company, an operation that offered guided tours and tent facilities for visitors in Yellowstone Park. Chester A. Lindsley, a long-time employee in Yellowstone Park, was designated supervisor when the newly formed National Park Service took over management of the park from the U.S. Army in 1916.

Charlie's reference to using hot geysers to wash out the reformers reveals, once again, his antipathy to any people who wanted to change any aspect of "God's country."

I Was at the Winnepeg Stampede
One watercolor and pen illustration; two pages, each 10 x 8⅞ inches
Signed CM Russell (letter); illustration not signed; ca. July 1917
Ex-collections: Maynard Dixon, San Francisco, California
 Mrs. Edith Hamlin, San Francisco, California
 F. G. Renner, Washington, D.C.

Few public affairs had a greater attraction for Russell than a roping and bronc-riding contest, and it was with regret that he had to turn down an invitation from famed California artist Maynard Dixon to attend the Pendleton Roundup. But if Dixon's invitation was turned down, Charlie's wasn't. A few weeks after this exchange of letters, Dixon and Frank Hoffman, a noted New York illustrator, came to Bull Head Lodge. The two artists collaborated on illustrating one of the famous screens for which the lodge was noted.

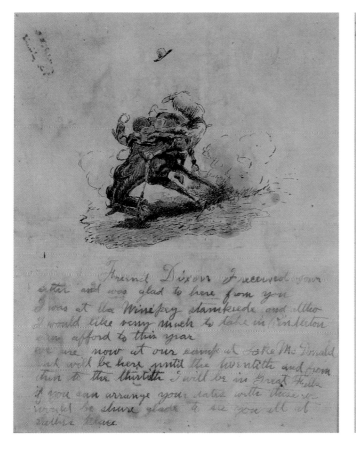

Friend Dixon I received your
letter and was glad to here from you
I was at the Winnipg stampeede and Calgary
I would like very much to take in Pendleton
if I can afford to this year
we are now at our camp at Lake McDonald
and will be here untill the twentieth and from
then to the thirtieth I will be in Great Falls
If you can arrange your dates with these we
would be shure glad to see you all at
Bulls Place

I received the magazines and think your pictures
were fine they looked mighty real to me
your Indians ponies and lodges were all
mighty skookum
I am glad of your success and hope you keep
pulling of good things till your light goes out
and hope it burnes long and bright with out
a flicker
I saw some good riding at the stampeed but
a good many of them were unloaded
most of the horses were old out laws from montana
and alberta and them twisters had to ride
to get the money cause those bronks went
high wide and crooked
I have never been to Pendleton but have heard
they pull of good riding and roping there
and I think it will pay you to go
now Dixon dont forget if you cut my range
dont pass my camp
I leave the first of oct for a hunting trip and
will be gon about two weeks
 with best wishes to you both
from my wife and I
 your friend
 C M Russell

PROBABLY JULY OR AUG. 1917 - C.D.

The Bear Paw Pool
One watercolor and pen illustration, 8 x 10 inches
Signed lower left, CM Russell, ca. 1896
Ex-collections: Jesse Phelps, Utica, Montana
 Buckholz Galleries, Bradford, Pennsylvania

The "Bear Paw Pool" was an association of ranchers from three Montana counties who joined forces each year for the fall roundup. The OH brand on the near horse and wagon cover in Russell's illustration identifies the owners as Preuitt and Phelps, the latter the "Friend Jess" to whom the note is addressed. The friendship went back a number of years. It was to get Jesse Phelps off the hook in reporting the decimation of Kauffman and Stadler's cow herd that Charlie created *Waiting for a Chinook*—and thereby took his first step into history.

 In the years 1894–1897, when Russell lived in Cascade, a commission for two "pictures" from Jesse Phelps would have been as welcome as a chinook in January.

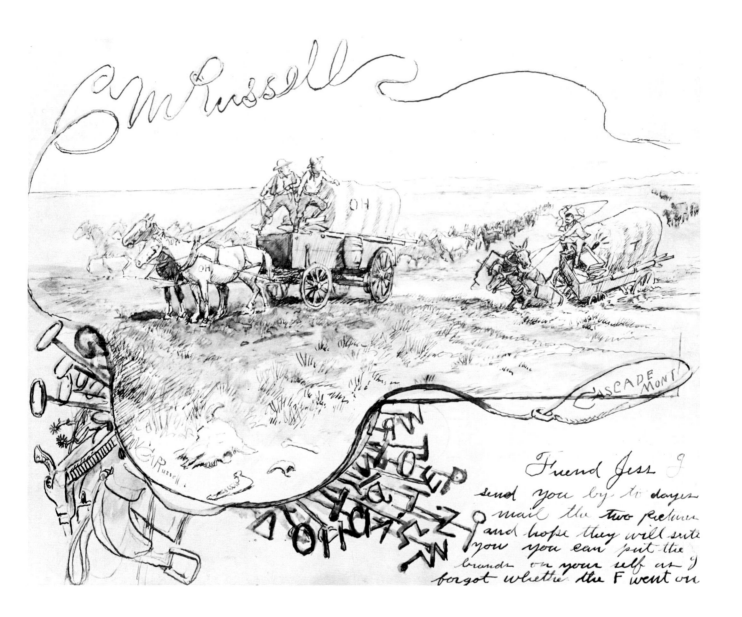

C M Russell

CASCADE MONT

Friend Jess I
send you by to dayes
mail the two pictures
and hope they will suite
you you can put the
brands on your self as I
forgot whether the F went on

C. M. RUSSELL
GREAT FALLS, MONTANA

April 15

My dear Mr Goodwin

I am sure you will
be pleased with the
enclosed. We had a
dandy trip home just
arrived last night after
being water bound in
the floods of the south
and snow of the west

I think you will be
somewhat surprised to
hear Bill Krieghoff came
home with us

I have a lot of letters
to day this is only
a note to send you the
check.

Kindest regards
to the Goodwin family
from the Russell

sincerely
Nancy Russell

My Dear Mr. Goodwin
Non-illustrated letter from Nancy C. Russell; ca. 1905

The April 15 letter to Phillip R. Goodwin was, in all likelihood, written in 1905. Charlie and Nancy had just returned to their Great Falls home following an extended trip to New York, with a leisurely visit to Charlie's family in St. Louis on their way back west. Goodwin, an up-and-coming illustrator and wildlife painter, had been a student of Howard Pyle and was, at the time, just getting well established in the New York publishing market. In subsequent years, he visited the Russells many times, often making extended stays at Bull Head Lodge.

The formality of this salutation would indicate the friendship had just been established that winter. However, that didn't stop Nancy from arranging to sell one of Goodwin's paintings, the check for payment being transmitted with this letter.

How Good Fren
One watercolor illustration, 8½ x 6¼ inches
Signed Ah wa cous (letter); envelope illustrated; illustrations not signed; July 1907
Ex-collections: John Matheson, Great Falls, Montana
J. N. Bartfield Galleries, New York, New York

John Matheson was known throughout Montana as the "last jerk-line" man in the area. He had a minimum academic education, but he spent his life reading everything from the Bible to Tolstoy. And he was Charlie Russell's friend from the time the kid first came west.

In the spring of 1910, Matheson finally realized that the Great God Progress (in the disguise of the Great Northern Railroad) was going to overwhelm him and, reluctantly, he let it be known he was selling out. Russell interrupted a busy year to spend two weeks traveling from Fort Benton to Utica and Great Falls with his friend and a fourteen-horse span hooked to the wagons. He wrote of the trip to his good friend, Phil Goodwin: ". . . baring a bad snow storm we had a fine trip. we were snowed in so we didn't turn a wheel for three days but we were comfurtible John slept in his cookcart and I in the trail wagon an theres no better snoosing place than a big Murphey wagon with the roar of the storm on the sheets nature rocked my cradel and sung me to sleep."

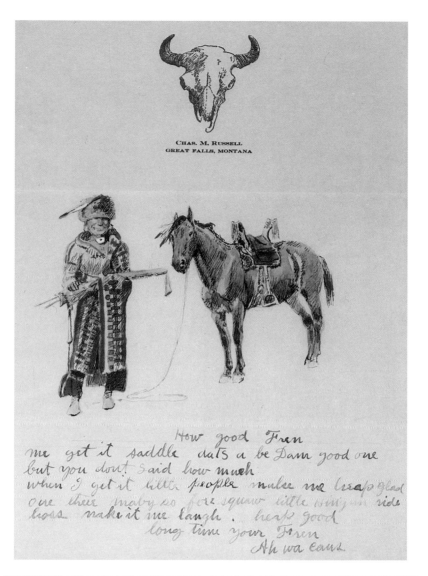

CHAS. M. RUSSELL
GREAT FALLS, MONTANA

How good Fren
me get it saddle dats a be Dam good one
but you dont said how much
when I get it little people make me heap glad
one these maby so for squaw little wimmin ride
hoss make it me laugh. heap good
long time your Fren
Ah wa cans

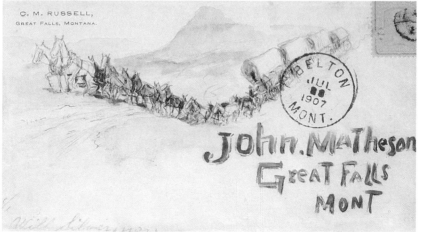

C. M. RUSSELL,
GREAT FALLS, MONTANA.

John. Matheson
Great Falls
Mont

I Never Knew a Cowman to Ware Anything but Silk
Two watercolor and pen illustrations, four pages, each 10¼ x 6½ inches
Signed CM Russell (letter); illustrations not signed; 1924

Charlie's contempt for "latter-day cowboys" knew no bounds, and he never passed up an opportunity to compliment a writer who knew what the Old West was all about. The recipient of this laudatory letter was the much younger half-brother of Wallace Coburn, whose book, *Rhymes from the Roundup Camp* was illustrated by Charlie. The Coburn boys' father, Robert, had been a prominent rancher in the Judith Basin. His Circle C ranch, whose foreman was Horace Brewster, was the site of a brief and friendly encounter between Bob Coburn and Chief Joseph of the Nez Perce. The Coburn family greatly treasured a long elk-tooth necklace, a feathered war bonnet, and a handsome peace pipe given the rancher by the beleaguered, fleeing, yet noble Indian chief.

Cowboy Shooting Rattlesnake
One pen drawing; two pages, each 8½ x 4¾ inches
Signed CMR (skull) 1898; letter signed, CM Russell (includes letter from Nancy Russell)
Ex-collections: Robert Thoroughman, Cascade, Montana
 Mrs. Eula Thoroughman, Fort Shaw, Montana
 F. G. Renner, Washington, D.C.

Keeping the wolf from the door was a struggle during the early days of the Russell marriage, and a gift of chickens was a welcome addition to the larder. Bob Thoroughman, the recipient of this thank-you note (and by 1898 a successful Montana rancher), knew the addition of a house guest would strain the resources of Charlie and Nancy at a time when Nancy, in particular, wished to make a good impression. For this was Mr. Charles Silas Russell's first trip to Montana. So pleased was he over his son's choice of a wife that he contributed substantially in helping the young couple acquire land on Great Fall's north-side for a home site.

108

it was in late years I've san
riders that looked like this sketch
this kind' oie generly found
around a soft drink parlor
I dont know whether its coco
cola ore mapel met sunday
that worps his legs the wrong
way but I do know
no cow puncher I ever knew
if he was going to ride
a Snake would take
every thing soft as a brave maker
this cococola soke can tell whats the
matter with a ford by the nois
it makes but he wouldent know
that a wet cold horse with a hump
in his back is dangerous
Shaps spurs and boots and big hat
dont make riders
neather dos bib overalls and caps
make pictures ore storyes

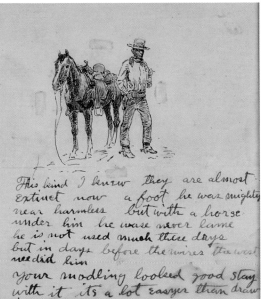

This kind I knew they are almost
extinct now a foot he was mighty
near harmless but with a horse
under him he wase never lame
he is not used much these days
but in days before the wires the west
needed him
your modling looked good stay
with it its a lot easyer than draw
ing

we have just been trooling
arown the kountry since he
came give my love to grand
ma and except a share your
self yours sincerley
 Mame Russell

P S tell Mr Thoroughman
that Father Russell did
know Mr Tom Thoroughman
quite well

Mr. R. P. Thoroughman
 Cascade
 Mont

Friend Bo we
rocived the chickens
and thank you awhollot
would have written sooner
but have been out of
town my Father is
here we have just returned
from loging creek we caught
all the fish in that country
 I dont think

with best regards
to yourself and
family yours bull
of chicken C M Russell

Dear Mrs Thoroughman
the chickens were lovley
we enjoyed them so mutch
it is a shame we did not
wright sooner but we have
been so occupied that we did
not have time we have had
sutch a delitefull vist with
Father Russell I think he
is the dearest old man
I ever saw I fell in love with
him the first time I saw him

Wild Men That Parkman Knew
One watercolor illustration, 13¼ x 6½ inches
Signed CM Russell, 1921
Ex-collections: W. M. Armstrong, Los Angeles, California
 Clara Peck, New York, New York

No words of explanation need be given on the letter Charlie Russell wrote to his patron, William Armstrong, in April of 1921. The reader knows from the text that creating fifty small jewels in Armstrong's copy of Parkman's *Oregon Trail* was not labor. In doing the very personal illustrations, the artist was transported back in time to that remarkable summer of 1846. Throughout his life, Charlie often expressed just such a desire.

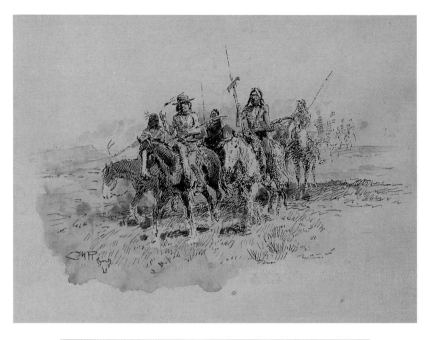

W. M. Armstrong
 Los Angeles Calif
 April 7 - 1921

Friend Armstrong
 I call you this as I count all those
who love the old west friends
The brown herds and wild men that Parkman
knew and told of so will have gon
The long horned spotted cows that walked the
same trails their humped backed cousins made
have joined them in history and with them
went the wether worn cow men
They live now onley in bookes The Cow puncher
of forty years ago is as much history as
Parkmans Trapper. The west is still a
great country but the picture and story
part of it has been plowed under by the
farmer. Prohibition maby made the west
better. But its sinch bet Such Gents as
Trappers Traders Prospectors Bull whackers
Mule Skinners Stage drivers and Cow punchers
dident feed up on Cocola ar Mapel nut
Sundais
To make sketches in Francis. Parkmans books
has been a pleasure to me
When I read his work I seem to live in his
time and travel the trails with him
 Wishing you and yours health
and happyness

Your friend
 C M Russell

C. M. RUSSELL
GREAT FALLS, MONTANA

Oct 5 1924

Friend Con

I got your letter some time agor we were sorry to here of Leslies illness I hope hes all well by this time we have been home from the lake over a month we had a couple of hoses up thair and I rode every day it done me lots of good I belive a horse is a good Doctor for most eney sickness I am in pritty good shape now saw Mike Conley the other day he asked all about you Horis Bruster still holds his job at the Park he told me that Charley his brother died last fall in Canada Henery Kuten comes over once and a while and we drift back on old trails that are plowed under now

I am sending you another elk tooth when it comes dark yond better slip this one in your sock along with your role I hope this tooth brings better luck did you know Tex Hunter Tex has been runing booze over the line he got to much of his own goods in him and went to war he shot at a man that was with his wife missed on grazed the man but keilled his wife this all hapened at Sweet Grass

things look cloudy for Tex it looks lik hel make hair britler for a long time

things are looking better this year than they were last up here we may come to Cal after New Year if we do Il try and see you I hope you all are all well with best wishes to you and yours your friend

C. M. Russell

To Con Price
Non-illustrated letter, two pages
Signed CM Russell, October 5, 1924
Ex-collections: Hooper Jackson, San Francisco, California
 F. G. Renner, Washington, D.C.
 Hammer Galleries, New York, New York

The letter to Charlie's old friend, Con Price, who was living in Southern California at the time, is not illustrated, but it is precious because of its text. An explanation of the people mentioned reveals some of the many facets of Russell's character and personality. Charlie expresses concern for Leslie, Con's only son. He reveals his pleasure in once again riding horseback after months of a sciatic attack had precluded such activity. He speaks of Mike Conley, who had cowboyed with both Charlie and Con in the Judith Basin, and who had been in charge of the cattle train to Chicago on Con's first trip to the "hog-and-cattle butcher of the world." Horace Brewster was foreman for the first cattle drive Charlie ever worked and was a respected and well-known cowman in Montana. Henry Keeton also cowboyed with Russell and Price and ended his days living in a house immediately behind Charlie's. He rode in the cortège at Russell's funeral. The remarks about Tex Hunter are typical of Russell. Things happened to people and there would be consequences from their actions, but Charlie would never make a judgment against them unless, of course, they were "nesters or reformers."

C. M. RUSSELL
GREAT FALLS, MONTANA

May 9
1925

Friend Con

I received your letter a long time ago
I dident answer
the only reasing I dident have aney
thing to write about

they had a Stock Convention here last month
I did not know many a few old timers
like Lewi Kauffman and Mc lamara Harris
one or two more the only Cow punchers
of my time was Teddy Blue and Bandy Buck
Teddy wouldent ware a badg cause he said they
were hanging them on sheep men
Buck hasent drank for a long time but
he sliped at the convention and like all
of his blood he went back to his mother
Side he Shure was Injun
Mike Conly lives here and I see him some
times
an old cow puncher nane Rose told he knew
you & said Charly Ferral is dead
Bill his still living and is well fixed
I dont no whether I told you before
but Old Dad. Marsh died last fall
when the Angel of death sent whissin to sleep

She was merceful poor Marsh had been
in bed six years
Saw Tom Daly not long ago hes Sheriff now
and lookes good about all he has to do is
Chase boot leggers and I think Tom lets lots
of them get away
Mamae is down in Los Angles now I dident
go if you are Clandy happen to go that
way in the next three weeks you will
find her at the Bilt More hotel
Con I sent you another Elk tooh did you
Ever get it I hope if you did you'l have
better luck with it
Jack is eight years old now and tall he likes
to ride horse back I have two horses at the
Lake and when we go to the mountians
we ride to getter

 well Con Il close for this
time
 with best whishes
 to you and Yours
Your friend.
 C M Russell

To Con Price
Non-illustrated letter, two pages
Signed CM Russell, May 9, 1925
Ex-collections: Hooper Jackson, San Francisco, California
 F. G. Renner, Washington, D.C.
 Hammer Galleries, New York, New York

In the last years of his life, Charlie took great delight in reminiscing with or about old friends; he called it "back-trailing." The annual stock convention was an event he anticipated, because it was a gathering from around the state of the "regular men" Charlie so admired. Louis Kauffman had been a butcher in Helena and owned large cattle herds in the Judith area when Russell first came to Montana. Edward "Teddy Blue" Abbott had come up the Texas Trail and had cowboyed with Price and Russell in the Judith roundup and with the Bear Paw Pool. Baldy Buck was a half-breed cowboy from Lethbridge, Alberta, a long-time friend of both men. Old Dad Marsh had been the owner of the only hotel in Big Sandy, holding a reputation of being a friend to all the cowboys coming in from the spring and fall drives, feeding and bedding down many of them during the out-of-work months they all experienced. Tom Daly had been on the cattle train to Chicago with Con Price, and they had worked together for the DHS outfit on the Milk River. These were years when Nancy often traveled alone, setting up and working art shows, seeing patrons, and engendering publicity stories on Charlie—a totally liberated woman, a phenomenon at that time.

115

Coming West
One watercolor illustration, 11¼ x 5⅛ inches
Signed CM Russell (letter); illustration not signed; July 30, 1926
Ex-collection: Isabel Brown Hall

This is one of the last of the artist's hundreds of famous illustrated letters. Russell had just returned to his beloved Bull Head Lodge in Montana from the Mayo Clinic and had less than three months to live when he wrote this letter to Isabel Brown. Miss Brown was the young daughter of long-time friends of the Russells and, with her parents, had enjoyed a vacation at the lodge. Charlie, who not only loved children but had a special rapport with them, must have been especially touched by Isabel's expressed concern for his well-being.

July 30
1926.

Miss Isabel Brown
 Dear Miss Isabel
I received your kind letter and was
glad to here from you
When I get aney thing in the mail
thats not a bill it a safe bet its
from a friend
I got more letters while I was in
Rochester than ever before in my hole
life but not one from an
under taker
Miss Isibel my friends gave me nerve
to go up against the knife
I glad I went to Rochester but the best
end of the trip was coming west

as I said before I got letters
from maney friends
but yours was from my youngest
friend
to write a letter takes time and young
folks use a lot of that
and whene they use aney of it on
me I appreciate it
wer all up at Lake MacDonald haveing
a good time
I m weak yet but am getting back
slow
 With best wishes to you
 Your Father and Mother
 Your friend
 C M Russell

Redbird #3 (Original Model)
Clay, 4⅜ x 5³⁄₁₆ x 2¾ inches
Signed CMR (skull) 1926
Ex-collection: Isabel Brown Hall

Authorities disagree on the correct line of succession of Russell's horses. Following Monte, his first and most beloved horse, came Neenah, some say. Others list Grey Eagle or Redbird. All of Charlie's horses were dear to him, well cared for during their working lives and lovingly pastured in their old age. The end of Redbird was a touching event. Ill with rheumatism, the sorrel had to be destroyed in 1908. Friends offered to relieve Charlie of the task, knowing how sentimental he was about his horses. Charlie refused. Before dawn he rose and, strapping on his six-shooter, he led the animal far out on the prairie. Without looking directly at the horse, Russell pressed the gun to Redbird's head and pulled the trigger, ending long months of pain for his faithful friend. Russell rushed home, went to bed, and refused to talk to anyone the rest of the day. It had been a shattering obligation for the gentle artist.

Redbird
Bronze, 4⅜ x 5 x 2⁹⁄₁₆ inches
Signed CMR (skull) 1926; Modern Art Foundry; numbered 2/30
Ex-collection: Isabel Brown Hall

It is obvious Russell was deeply touched by a get-well letter sent to him at the Mayo Clinic in the summer of 1926. He not only replied with an illustrated thank-you note to the young sender, Miss Isabel Brown, but he also gave her this beautifully modeled sculpture. It was, in all probability, one of the last pieces of sculpture made before the artist's death.

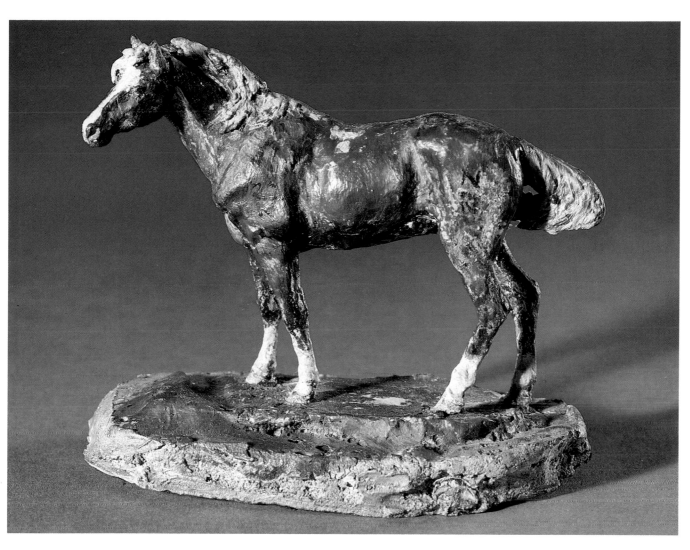

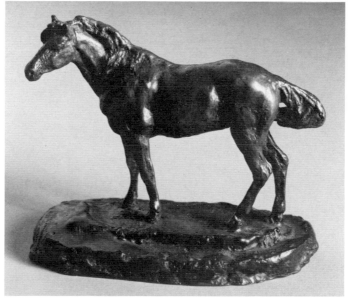

To Noses That Read a Smell that Spells Man
Bronze, 4½ x 8¼ x 6¾ inches
Signed CM Russell (skull); Inscribed: To Noses that Read a Smell that Spells Man—RBW
Ex-collection: Grand Central Galleries, New York, New York

The grey wolf may have been a skulking, snarling scavenger of the plains, but in Charlie's eyes, the animal's keen senses set him apart. Time and again, Russell painted or modeled the wolf in a wary, alert, or forceful manner.

Although modeled in 1920, *To Noses That Read* was not cast until 1925, and it was first exhibited at the Corcoran Gallery of Art, Washington, D.C., February 3–27 of that year, in a "Special Exhibition of Paintings and Sculptures by Charles M. Russell."

Turkey
Bronze, 4⅝ x 2⅞ x 2¾ inches
Signed CMR (skull); No foundry mark (Cast by Roman Bronze Works, Inc., New York, in 1963, in an edition of twelve)
Ex-collections: F. G. Renner, Washington, D.C.

No one loved holidays more than Charlie Russell, and he often produced watercolor sketches for place cards as well as models for table decorations for special occasions. It is probable that this sculpture was a Thanksgiving Day gift to his long-time friend, Kit Roberts.

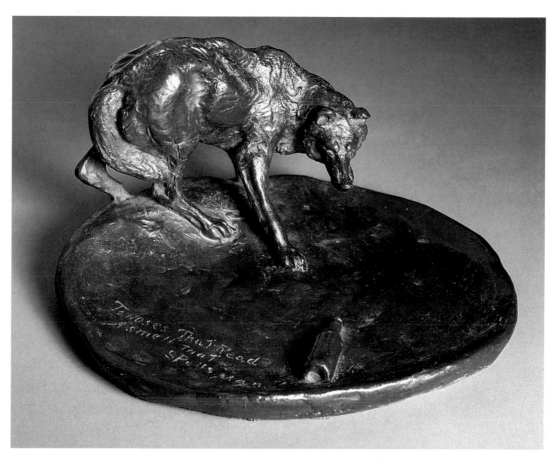

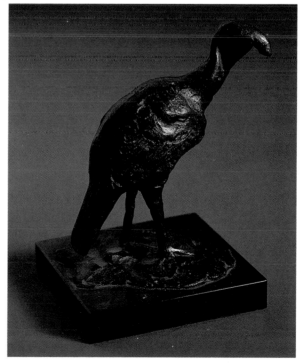

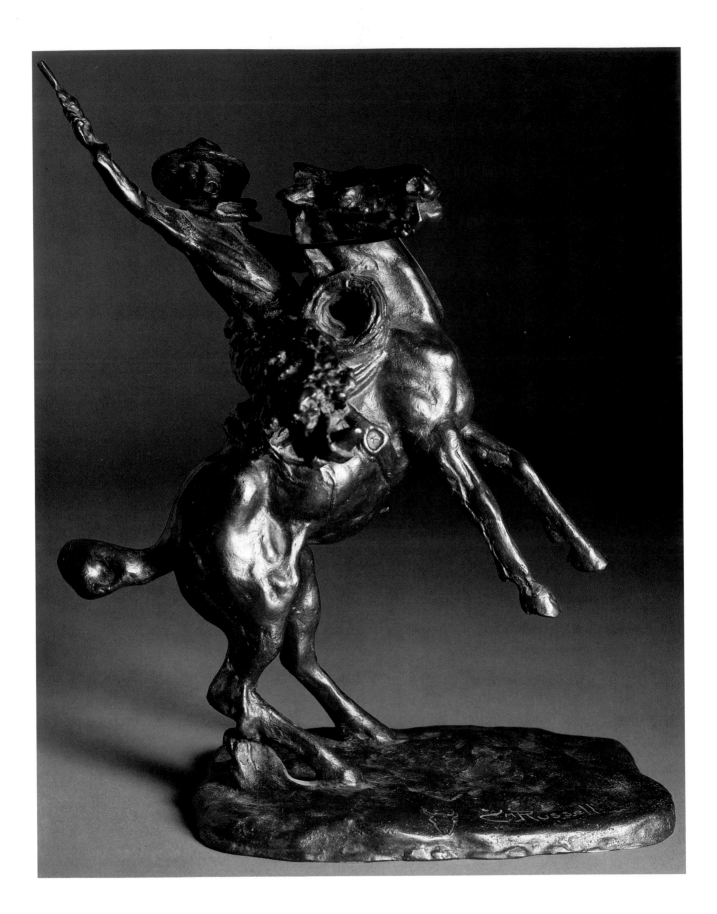

Smoking Up
Bronze, 12 x 10½ x 6¾ inches
Signed CM Russell (skull); Roman Bronze Works, Inc., New York
Ex-collection: Helen Card, New York, New York

The Russells' first trip to New York in 1903 was, in many ways, a harrowing experience. While Nancy was out meeting publishers, seeing gallery owners and, in general, attempting to break into the art market, Charlie was left alone a good deal. The big city with its fearsome noise and surging traffic frightened the cowboy from Montana, and he spent many hours in a small hotel room on West 48th Street. It was during this time he modeled the sculpture, *Smoking Up*. The model so pleased his new-found artist friends that they persuaded him to have it cast in bronze, the first of his sculptures to be so handled.

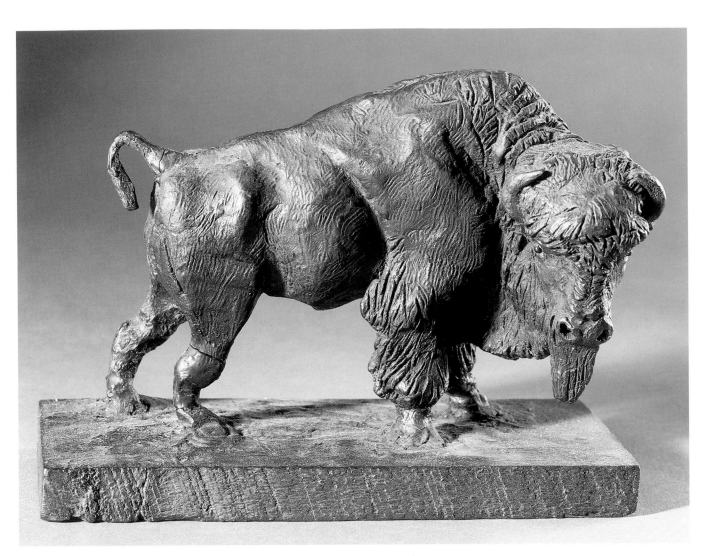

A Russell Buffalo (Original Model)
Wax on wood base, 6⁹⁄₁₆ x 8¹⁵⁄₁₆ x 3¾ inches
Signed CMR (skull) 1901
Ex-collections: LeRoy Fogle, Great Falls, Montana
 Harry N. and George L. Fogle, Los Angeles, California
 Leonard Lombardo, New York, New York

This sculpture was one of two Russell gave to his friend, LeRoy Fogle, in 1901. The artist modeled one of his favorite subjects as "the last of his breed." The old bull has a maimed horn, sure sign of long years of aggressive defense of his territory. His head hanging low, he stands weary and uncertain, yet his tail is elevated, slightly curled, an indication of his continuing will to fight. With the exception of the range horse, no other animal elicited more admiration from the cowboy artist than did the buffalo of the plains. The editor of the *Great Falls Tribune* gave the sculpture its unimaginative title.

A Russell Buffalo
Bronze, 6⅔ x 5⅛ x 4⅔ inches
Signed CMR (skull) 1901; Modern Art Foundry, H. H. & G. L. Fogle 1961; numbered 18/30
Ex-collections: LeRoy Fogle, Los Angeles, California
 Peter Myers, North Hollywood, California

In 1961, when the sons of LeRoy Fogle decided to have the Russell models cast in bronze, they ran into difficulties in casting the buffalo in the foundries in Southern California. Resorting to help from an old friend, they had the first twelve bronzes of the edition cast by Francisco Zuñiga, the renowned Mexican artist, and his foundryman, Moises Del Aquila, of Mexico City.

125

Bessie B. (Original Model)
Beeswax on wood plaque, 8¼ x 6½ x 3½ inches
Signed CMR (skull) 1901
Ex-collections: LeRoy Fogle, Great Falls, Montana
 Harry N. and George L. Fogle, Los Angeles, California
 Leonard Lombardo, New York, New York

Bessie B. was a trotter who raced at tracks in Montana, Wyoming, Idaho, and North Dakota. Charles Russell and a Great Falls friend, Leroy Fogle, were partners in a quarter interest in the mare. It is speculated that Charles modeled *Bessie B.* and *A Russell Buffalo* in 1901, giving them to Fogle in lieu of his twelve and one-half percent interest. He did pay his portion of training, feed, and transportation bills on the trotter. LeRoy's son, George Fogle, said of the venture, "They didn't make a hell-o-va lot of money but they sure had a good time!" According to George, Russell used buttons from a pair of Mrs. Fogle's hightop shoes for the eyes in the Bessie B. model.

Bessie B.
Bronze, 6⅞ x 6½ x 3½ inches
Signed CMR (skull) 1901; Modern Art Foundry, H. H. & G. L. Fogle 1961; numbered 18/30
Ex-collections: LeRoy Fogle, Los Angeles, California
 Leonard Lombardo, New York, New York

Cast sixty years after it was modeled by Charlie Russell, *Bessie B.* is a lovingly created tribute to the artist's favorite subject. From earliest childhood, Charlie was closely associated with horses, and no other subject drew more of his artistic attention.

126

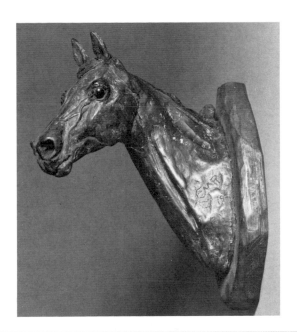

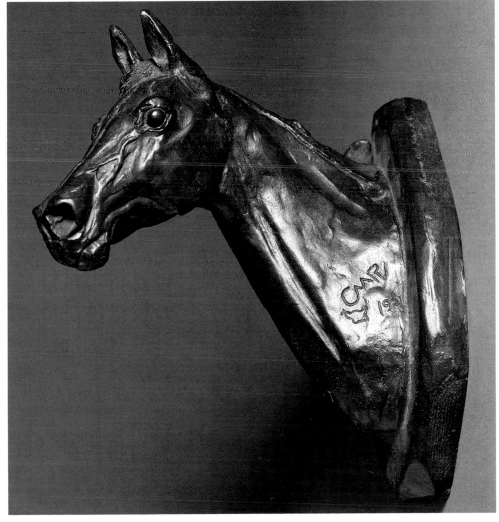

SELECTED
BIBLIOGRAPHY

Adams, Ramon, and H. E. Britzman. *Charles M. Russell: The Cowboy Artist, A Biography.* Pasadena, California: Trail's End Publishing Co., Inc., 1948.

Cheeley-Raban Syndicate. *Back-Trailing on the Old Frontier.* Great Falls, Montana: Cheeley-Raban Syndicate, 1922.

Coburn, Walt. *Pioneer Cattlemen in Montana: The Story of the Circle C Ranch.* Norman: University of Oklahoma Press, 1968.

DeVoto, Bernard. *Across the Wide Missouri.* Boston: Houghton Mifflin Co., 1947.

————. *The Year of Decision, 1846.* Boston: Little, Brown and Co., 1943.

Dobie, J. Frank. "The Conservatism of Charles M. Russell." *The Montana Magazine of History,* Vol. II, No. 2, p. 27, April 1952.

Ewers, John C. *The Blackfeet: Raiders on the Northwest Plains.* Norman: University of Oklahoma Press, 1958.

Gale, Robert L. *Charles Marion Russell.* Western Writers Series, No. 38. Boise: Boise State University, 1979.

Getlein, Frank (and the Editors of Country Beautiful). *The Lure of the Great West.* Waukesha, Wisconsin: Country Beautiful, 1973.

Lamar, Howard R., ed. *The Reader's Encyclopedia of the American West.* New York: Thomas Crowell Co., 1977.

Paladin, Vivian, ed. *Montana Stockgrower: Special Centennial Edition.* Helena: Montana Stockgrower's Association, 1984.

Parkman, Francis. *The Oregon Trail.* Edited by E. N. Feltskog. Madison: The University of Wisconsin Press, 1969.

Price, Con. *Memories of Old Montana.* Hollywood: The Highland Press, 1945.

————. *Trails I Rode.* Pasadena, California: Trail's End Publishing Co., Inc., 1947.

Rankin Papers. Copies of personal correspondence in the author's files.

Renner, Frederic G. *Charles M. Russell: Paintings, Drawings, and Sculpture in the Amon Carter Museum of Art.* New York: Harry N. Abrams, Inc., 1974.

————. *Paper Talk: Illustrated Letters of Charles M. Russell.* Fort Worth: Amon Carter Museum of Art, 1962.

Renner, Ginger K. "Charlie Russell and the Ladies in His Life." *Montana, the Magazine of Western History,* Autumn 1984, pp. 34–61, Helena: Montana Historical Society, 1984.

Russell, Austin. *Charles M. Russell, A Cowboy Artist, A Biography.* New York: Twayne Publishers, 1957.

Russell, Charles M. *Good Medicine: The Illustrated Letters of Charles M. Russell.* Garden City, New York: Doubleday, Doran & Co., Inc., 1930.

————. *Trails Plowed Under.* Garden City, New York: Doubleday, Doran & Co., Inc., 1931.

Schultz, James Willard. *Blackfeet and Buffalo: Memories of Life Among the Indians.* Norman: University of Oklahoma Press, 1962.

Stuart, Granville. *Forty Years on the Frontier: as seen in the journals and reminiscences of a gold-miner, trader, merchant, rancher and politician.* Edited by Paul C. Phillips. Glendale, California: The Arthur H. Clark Company, 1957.

Wade, Mason. *Francis Parkman: Historic Historian.* New York: Viking Press, 1942.

Yost, Karl and Frederic G. Renner. *A Bibliography of the Published Works of Charles M. Russell.* Lincoln: University of Nebraska Press, 1971.

INDEX
TO THE
COLLECTION

THE *OREGON TRAIL* ILLUSTRATIONS

THE ART

131

LETTERS

SCULPTURE